Things of perfection must not be looked at in a hurry,

but with time, judgement and understanding.

Judging them requires the same process as making them.

Nicolas Poussin to Paul Fréart de Chantelou, 20 March 1642

A Dance to

the Music of Time

by NICOLAS POUSSIN

Richard Beresford

The Trustees of the Wallace Collection, London 1995

Produced with the financial assistance of
TOTAL Oil Great Britain Limited on the occasion of a special
display held in Hertford House 11 January – 9 April 1995

Book packaged by John Adamson

Designed by Tim Harvey

Printed and bound by Balding + Mansell, Meridian House PLC

ISBN 0 900785 46 2
British Library Cataloguing-in-Publication Data.
A catalogue record for this book is available from the British Library.

Front cover:
Nicolas Poussin (1594–1665)
A Dance to the Music of Time
(Il Ballo della Vita Humana)
Canvas 82.5 × 104 cm.
The Wallace Collection, London (P108)

A large fold-out reproduction can be found at the end
of this book

Contents

Acknowledgements

I am grateful to many colleagues and friends who have assisted in various ways with the preparation of this book. Thanks are due to all of my colleagues at the Wallace Collection and especially to Robert Wenley, who wrote the essay on 'Poussin, Lord Hertford and British Collectors' and who was much involved with editing the text, and to Robert Peace who cleaned the bronze relief of the *Borghese Dancers* for the special display. I am also much indebted to Astrid Athen, Malcolm Baker, Geneviève Bresc, Duncan Bull, Gilles Chomer, Richard Cooke, Daniel Cunningham, Jill Dunkerton, Peta Evelyn, Brian Gilmour, Richard Green, Terence Hodgkinson, Katrina Kelveram, Alistair Laing, Herbert Lank, Christophe Leribault, Sir Denis Mahon, Elisabeth McGrath, Jonathan Miller, Jennifer Montagu, Angela Negro, Maxime Préaud, Katie Scott, John Sunderland, Noni Tasker, Jacques Thuillier, Richard Verdi, Humphrey Wine and Martin Wyld, to all of whom I offer many thanks. RB

Photographs: BERLIN, Staatliche Museen zu Berlin, Gemäldegalerie (photo Jorg P. Anders) 2; Staatliche Museen, Preussischer Kulturbesitz, Skulpturengalerie 1; DETROIT, Institute of Arts (© The Detroit Institute of Arts, Founders Society Purchase, Membership and Donations Fund) 28; DRESDEN, Staatliche Kunstsammlungen, Gemäldegalerie 29; EDINBURGH, National Gallery of Scotland (Department of Prints and Drawings) 33; LONDON, British Library 23, 26, 50; Trustees of the British Museum, 52; Courtauld Institute of Art 3, 10, 16, 51, 54, 57; Trustees of the National Gallery 30, 31; Network Photographers Ltd (photo Fay Godwin, copyright), 25; Trustees of the Tate Gallery 58; Warburg Institute 22, 24, 40, 41, 43, 46; NEW YORK, Metropolitan Museum of Art (Enid A. Haupt Gift, Gwynne Andrews Fund, and Purchase, 1871, by exchange. 1981.317) 6; PARIS, Bibliothèque de l'Institut de France (photo Agence Bulloz) 21; Bibliothèque Nationale de France, Cabinet des Estampes 5, 7, 14, 49, 55; Inventaire Général (photo Philippe Fortin, copyright 1985, Inventaire général – SPADEM) 56; Réunion des Musées Nationaux (© Photo R.M.N.) 4, 42, 45, 48, 60; ROME, Galleria Nazionale d'Arte Antica (Palazzo Barberini) 27; Istituto Centrale per il Catalogo e la Documentazione 9, 11, 13; Pinacoteca Vaticana 19; ST PETERSBURG, The Hermitage 15; STOCKHOLM, Kungliga Biblioteket 17, 18.

Preface

The book is dedicated to Terence Hodgkinson CBE
Director of the Wallace Collection 1974-78

The many successes of Terence Hodgkinson's enlightened and remarkable directorship of the Wallace Collection included the revitalisation of Poussin's painting *A Dance to the Music of Time*. When in 1975 he commissioned Herbert Lank to clean the picture, he initiated a close alliance between Herbert Lank and the Wallace Collection, and also an intriguing debate on the nature of the textured finger-print whorls in the priming layer of paint. It was Terence Hodgkinson's inspiration to invite the opinion of a finger-print expert at Scotland Yard, leading to surreal discussions as to whether the whorls could be thumb-prints from Poussin's own left hand.

Another of Terence Hodgkinson's achievements was to appoint John Ingamells to the Wallace Collection staff in 1977 (who was to succeed him as Director in the following year). John Ingamells served the paintings in the Wallace Collection better than any previous curator by publishing *The Wallace Collection Catalogue of Pictures* in four volumes between 1985 and 1992, rendering this area of the Collection the most comprehensively catalogued of all. While his catalogue will continue as our definitive work on the paintings at Hertford House for many years to come, we plan to publish the occasional additional monograph devoted to individual paintings or artists as new research and discoveries arise.

This monograph on Poussin's *A Dance to the Music of Time* has been master-minded by Richard Beresford who brings vision and depth to his lucid analysis of every aspect of the picture. I am most grateful to him and to Robert Wenley, his Hertford House colleague, who wrote the essay on Poussin, Lord Hertford and British Collectors. The Wallace Collection is also heartened by the continuing generosity of Total Oil Great Britain Limited whose assistance with this publication has rendered an imaginative proposal a reality.

Rosalind Savill
Director, The Wallace Collection

Introduction

A Dance to the Music of Time by Nicolas Poussin hangs, in normal circumstances, a few feet away from one of the greatest of Rubens's landscapes. The two pictures were painted probably within two or three years of one another, in the latter half of the 1630s.

In the *Rainbow Landscape* we share the uplifting experience of a vast sweep of landscape which, moisture-laden after a passing storm, is again flooded with sunlight. Ducks, cows, and men return to their various preoccupations while a rainbow embraces the landscape as the recurring symbol of God's love for His creation.

Rubens deals with Man's place in the scheme of creation and Poussin's theme is similar. The more correct title for *A Dance to the Music of Time* is *The Dance of Human Life*. But Poussin approaches his subject not through a direct response to nature, but in a poetic conceit expressed in the language of visual allegory.

Rubens's approach is more direct, and in many ways more modern. His vision of the natural order is derived from observation of nature, and that is a way of thinking with which we are all familiar. But Poussin's painting belongs to an older and less familiar tradition, one which sought to reconstruct the lost knowledge of the ancients by investigation of their art, literature and philosophy.

A Dance to the Music of Time presupposes a certain erudition on the part of the spectator which the *Rainbow Landscape* does not. It is the more demanding picture. It uses a language of symbolism which even the learned seventeenth-century spectator had difficulty in interpreting. And, while the symbolism itself is not complex, it refers to ideas which may now seem arcane.

How, in the late 1630s, did Rubens in Antwerp and Poussin in Rome come to paint pictures so different in character; one so direct, the other so abstruse? This cannot be explained simply by the personalities of the artists. Of the two, it was not Poussin, but Rubens who was at once the classical scholar and the undisputed master of allegorical composition. In Poussin's case we have to struggle to find any objective evidence that he was more than reasonably well educated and reasonably well read. Nor was he well versed in the genre of allegory.

More pertinent to the comparison is the fact that the *Rainbow Landscape* was painted by Rubens for his own satisfaction and remained in his own collection until his death. *A Dance to the Music of Time,* by contrast, was painted for a highly cultivated patron, Giulio Rospigliosi (later Pope Clement IX), who was not content simply with an example of Poussin's art, but himself dictated the subject to the artist.

This we know from the account of the commission given by Poussin's first major biographer, Giovan Pietro Bellori, who tells us that the invention of the subject was

Rospigliosi's and that Poussin was able to match in his art that sublime literary conception. There seems no reason to doubt Bellori's statement. Rospigliosi was a poet of considerable ability and, as we will see, his inventions for the stage have much in common with the poetic conceit which lies behind *A Dance to the Music of Time*. Thus the picture may be regarded, in a very real sense, as a work of collaboration between the poet-patron and the painter.

This is not the traditional view. A cursory glance at the critical history set out below will show that *A Dance to the Music of Time* has often been taken as a statement of Poussin's own philosophy. For Smith, writing in 1837, the picture 'prove[s] that the mind of the painter was strongly imbued with enlarged feelings of moral philosophy'. But the picture offers no such proof. If we consider Rospigliosi's role, it is apparent that Poussin's contribution was not that of the philosopher, but that of the painter in giving pictorial expression to the ideas of his patron.

If we approach *A Dance to the Music of Time* assuming these 'enlarged feelings of moral philosophy' on the part of the painter, our chain of logic is no less circular than the dance itself. A similar circularity can be observed in the false assumption (made by Coutil in 1924) that *A Dance to the Music of Time,* being a meditation on mortality and the passage of time, was painted by the artist close to death. The idea that the painter of *A Dance to the Music of Time* was a philosopher is no more substantiated by historical evidence than the idea that he was a dying man.

In considering Poussin's achievement, we should return to Bellori's statement that he matched in his painting the sublime quality of Rospigliosi's poetic conceit. For Poussin, though no philosopher, was a very great painter. He was able to create a visual image which can, like poetry, excite the imagination and carry the spectator to new planes of thought and understanding. No one who gives the picture time should emerge unchanged from the experience.

The chapters which follow offer a supplement to the catalogue entry on *A Dance to the Music of Time* which appeared in 1989. The present format permits greater generosity with respect to comparative illustrations and will allow a somewhat more discursive approach to the picture. It will be possible to touch on the life and character of the patron, to discuss the philosophical background for the subject, and to look in greater detail at the evolution of the composition, and the visual sources which may have inspired the artist. We also take the opportunity of tracing the history of subsequent reactions to the picture, while placing it in the context of the collection of which it is now irrevocably a part.

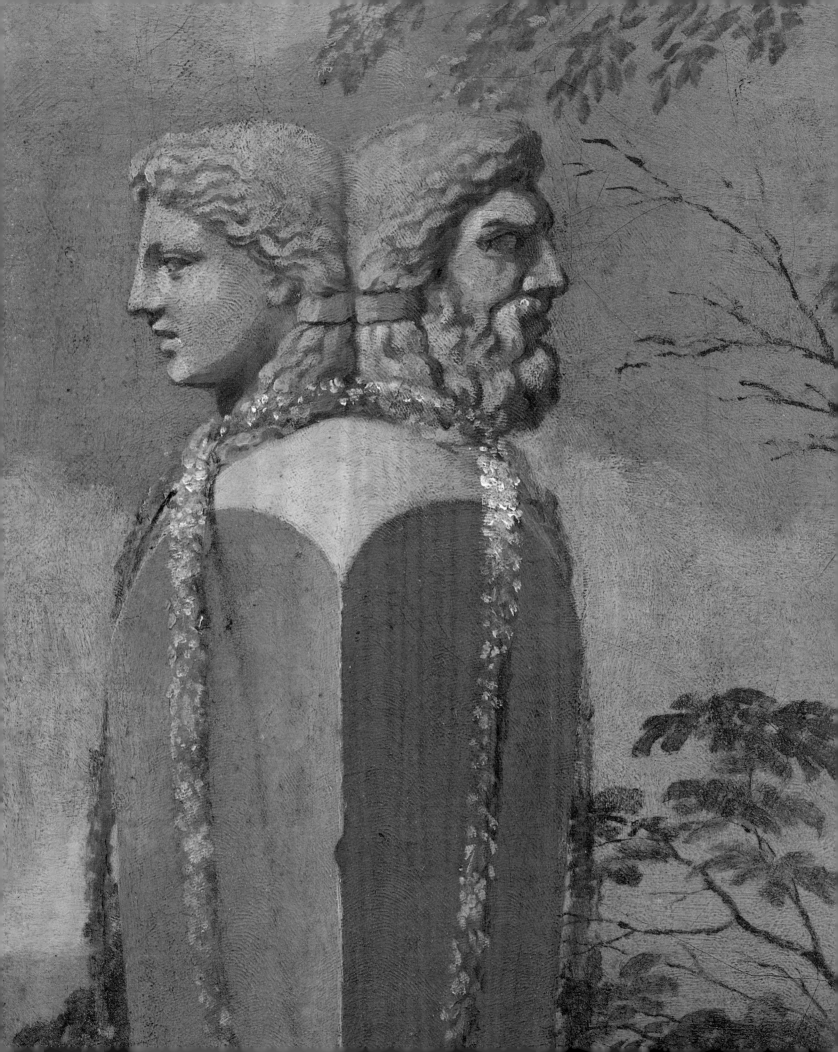

Poussin before 1640

1594	Born at Les Andelys, Normandy, where his father, Jean Poussin, had settled after pursuing a military career.
c.1605–9	Probably received at least a respectable education. It has been suggested that he studied at a religious college, perhaps that of the Jesuits in Rouen.
1612/13	Inspired by the visit of the painter Quentin Varin to Les Andelys to take painting as a career and travels, without parental consent, to Paris.
1612/13–c.1614	Trains briefly in the workshop of the late-mannerist painter Georges Lallemant, and with the Flemish portraitist Ferdinand Elle. Studies engravings after Raphael and Giulio Romano in the collection of Alexandre Courtois, *valet de chambre* to Marie de Médicis.
1617/18	Makes a trip to Florence, but returns to France without seeing Rome.
1618–19	Takes lodgings in Paris with a merchant goldsmith.
1619/22	Works in Lyon and plans to make the journey to Rome, but is prevented by financial problems and instead returns to Paris.
1622/3	Meets his first major patron, the Italian poet Giovanni Battista Marino, for whom he produces a series of drawings of mythological subjects and battle scenes (Royal Library, Windsor Castle).
1622–3	Paints festival banners for the Jesuits, an altarpiece for Notre-Dame and decorations in the Luxembourg palace for Marie de Médicis. All these works are lost.
1623/4	Makes the trip to Rome, possibly stopping *en route* in Venice.

Opposite: *A Dance to the Music of Time*
Detail of Janus Term

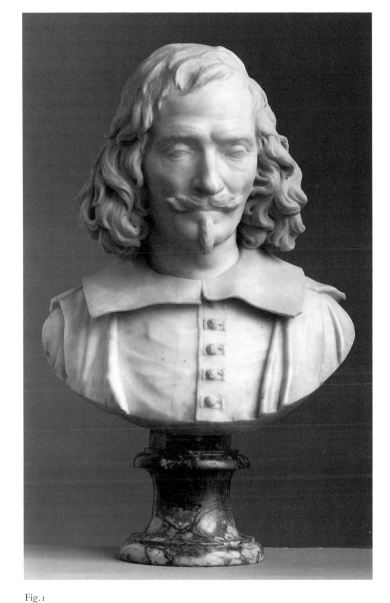

Fig. 1
François Duquesnoy (1594–1643)
Bust of Poussin?, c.1630
Marble
Height 70.5 cm.
Skulpturengalerie, Berlin
A bust by Duquesnoy recently acquired by the Sculpture Gallery in Berlin has been proposed as a bust of Poussin.

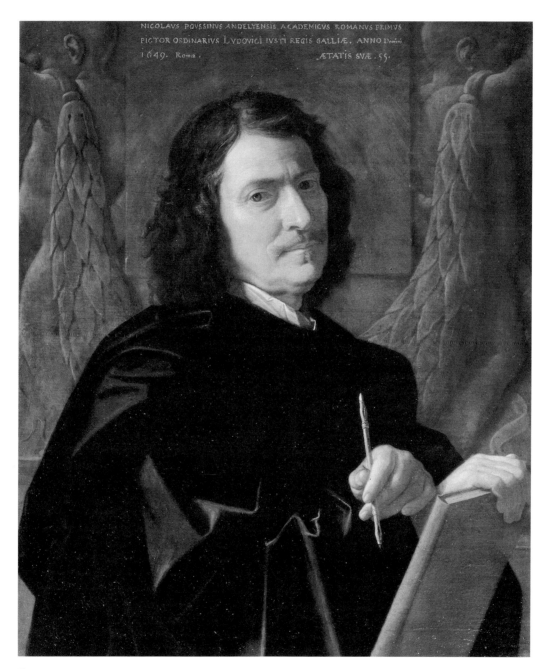

Fig. 2
Nicolas Poussin (1594–1665)
Self-Portrait, 1649
Canvas 78 × 65 cm.
Bodemuseum, Berlin

1624	Introduced in Rome to the court of Francesco Barberini, nephew of the recently elected Pope Urban VIII. Possible first meeting at Barberini's court with Giulio Rospigliosi (who later commissioned *A Dance to the Music of Time*).
1625	Cardinal Barberini commissions a *Capture of Jerusalem* (now lost), but immediately leaves Rome on legations to Paris and Madrid, on the latter occasion accompanied by Rospigliosi.
1626	Shares lodgings with the Flemish sculptor François Duquesnoy (1594–1643) with whom he studies Titian's *Bacchanals* and *Worship of Venus* then in the Villa Aldobrandini (now National Gallery, London, and Museo del Prado, Madrid). His works at this period are strongly influenced by the Venetian school and the majority treat mythological subjects. Cardinal Barberini commissions the *Death of Germanicus* (Minneapolis Institute of Arts).
Mid-1620s	Falls ill, probably with syphilis, and is nursed by the family of a fellow French expatriate, Jacques Dughet.
1628	Cardinal Barberini commissions an altar-piece for St Peter's of the *Martyrdom of Saint Erasmus* (Pinacoteca Vaticana, Rome).
c.1629–30	Paints an altar-piece of the *Vision of the Virgin to St James* for Valenciennes (Musée du Louvre, Paris). This would be his last essay in a truly Baroque idiom; he generally worked thereafter on a smaller scale for private clients.
1630	Marries Anne (or Anne-Marie) Dughet. He would later teach the art of painting to his brothers-in-law Gaspard and Jean Dughet, of whom the former became a celebrated landscape painter and the latter, less talented, acted as Poussin's secretary and engraved some of his works.
1630–1	Paints the *Plague at Ashdod* (Musée du Louvre, Paris) and the *Kingdom of Flora* (Gemäldegalerie, Dresden) for Fabrizio Valguarnera. In the following years his art develops swiftly, and with constant experimentation, the general trend being towards greater simplicity, clarity and geometric structure.
1633	Signs and dates the *Adoration of the Kings* (Gemäldegalerie, Dresden).
Mid-1630s	Especially favoured from this period by Cassiano dal Pozzo, secretary to Francesco Barberini and a learned antiquarian, from whom he receives numerous commissions.
1634	Paints the *Saving of the Infant Pyrrhus* (Musée du Louvre, Paris).
1634/5	Paints the *Adoration of the Golden Calf* (National Gallery, London) for Amadeo dal Pozzo, Cassiano dal Pozzo's cousin.
1634–6	Paints a series of *Triumphs* for Cardinal Richelieu, the only undisputed picture which certainly comes from this series being the *Triumph of Pan* in the National Gallery, London. Some scholars place *A Dance to the Music of Time* within this period (though they remain in the minority).
1636/8	Embarks on a major series of canvases for Cassiano dal Pozzo representing the *Seven Sacraments* (National Gallery of Art, Washington, and Belvoir Castle, Rutland) which display a scrupulous attention to archeological detail reflecting the antiquarian interests of the patron.
1637	Paints *Camillus and the Schoolmaster of the Falerii* for Louis Phélypeaux de La Vrillière, Secretary of State to Louis XIII (Musée du Louvre, Paris).
1638	Begins the *Gathering of Manna* for Paul Fréart de Chantelou and paints the *Finding of Moses* (both Musée du Louvre, Paris).
1638–40	*A Dance to the Music of Time* is normally placed in these years.
1639	Ordered by the King to return to France.
1640	Paints the *Landscape with St Matthew* (Gemäldegalerie, Berlin), the *Landscape with St John* (Art Institute Chicago) and the *Continence of Scipio* (Pushkin Museum, Moscow) for Gian Maria Roscioli. Poussin leaves Rome on 28 November for Paris to take up the appointment of First Painter to the King. This is a major turning point in his career. In Paris he worked mainly on altar-pieces and decorative schemes. The period was not a happy one and Poussin returned definitively to Rome in 1642. He left unfinished the vast project for the decoration of the *grande galerie* of the Louvre.

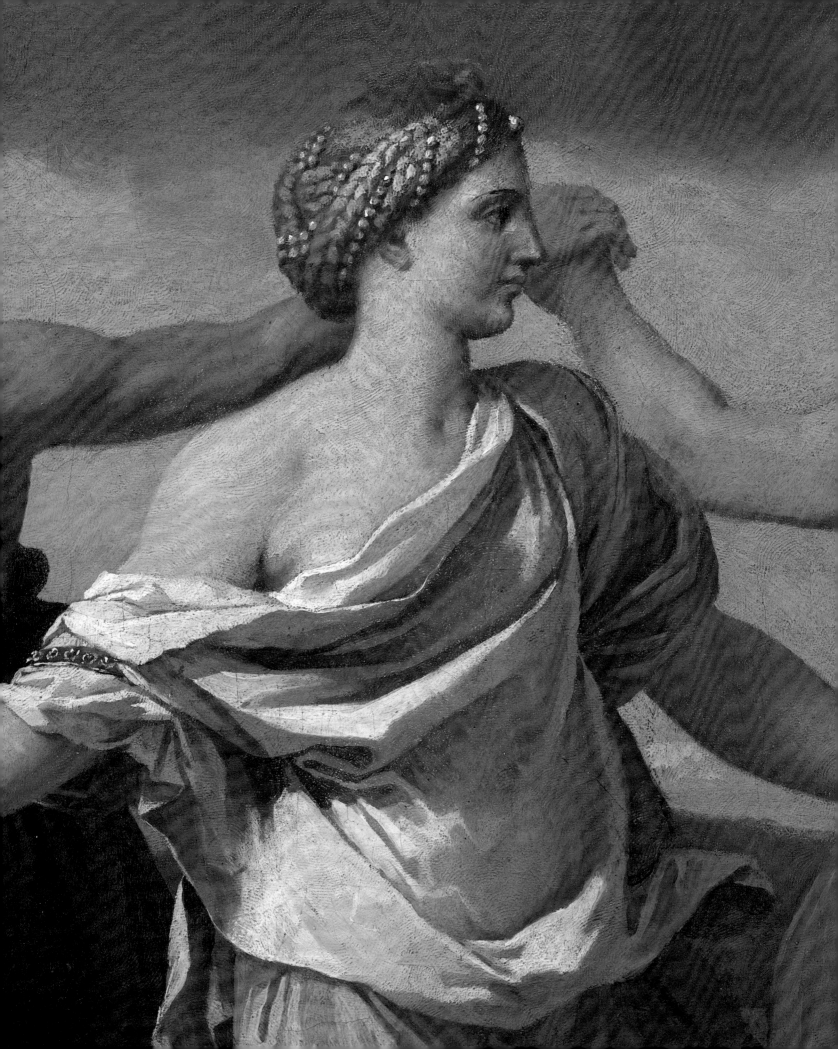

The Patron: Giulio Rospigliosi

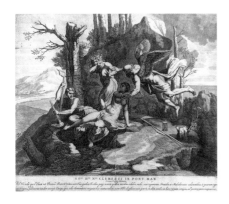

Fig.3
After Nicolas Poussin (1594–1665)
Time Saving Truth from Envy and Discord,
1667/9
Engraving by Etienne Baudet (1638–1711)
and Jean Dughet (1614–76)
Courtauld Institute of Art, London
The painting, now lost, probably dates from
the last years of the 1630s and was almost
certainly commissioned by Rospigliosi who,
according to Bellori, provided the subject.

Right: Fig.4
Nicolas Poussin (1594–1665)
The Arcadian Shepherds, c.1638
Musée du Louvre, Paris
Canvas 85×121 cm.
According to Bellori the subject was given to
Poussin by Rospigliosi, but it seems not to
have been his 'invention' as the same subject
had been treated before both by Guercino
and Poussin. The picture may have been
commissioned by Rospigliosi, but does not
appear in later family inventories.

Opposite: *A Dance to the Music of Time*
Detail of Wealth

In his biography of Poussin of 1672, Giovan Pietro Bellori refers to a group of three pictures – which he describes as 'moral poems' – for which the subjects were devised by the patron Giulio Rospigliosi (see p.64). They were *A Dance to the Music of Time, Time saving Truth* (Fig.3) and the *Arcadian Shepherds* (Fig.4). Bellori does not actually say that Rospigliosi commissioned the pictures, but this seems to be the implication. It is all but certain in the case of the first two, because they are later recorded in the collection of Rospigliosi's nephew and heir.

Bellori's statement that Rospigliosi devised the subjects has to be treated with some suspicion. The *Arcadian Shepherds* was not an original subject; it had earlier been treated both by Poussin and Guercino.[1] Nor was *Time saving Truth* a new subject, though the precise formulation of the allegory *(Time saving Truth from Envy and Discord)* was possibly a new variant on a traditional theme.[2] But in neither case can Rospigliosi be credited with inventing the subject. So Bellori may simply mean that Rospigliosi chose the subjects, perhaps offering some advice as to how they should be treated. However, as will be argued in the next chapter, *A Dance to the Music of Time* is different. The subject here is

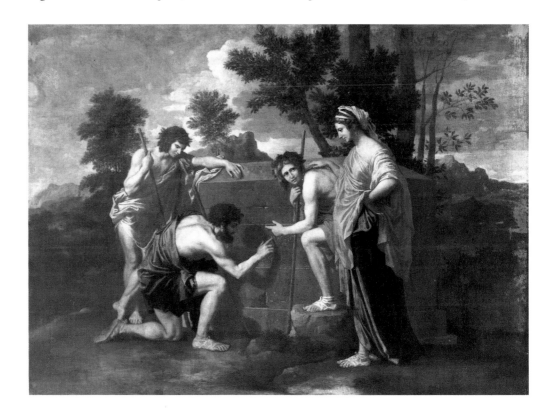

new and seems to proceed naturally from Rospigliosi's own interests in poetry and opera. There seems little reason to doubt Bellori's evidence that he devised it.

The Prelate

Giulio Rospigliosi (1600–69) is known by some as a patron of the visual arts, by others as one of the leading figures in the early development of Italian opera, by others still as Pope Clement IX. His wide-ranging attainments seem to have included an irreproachable character: according to all accounts he was modest, courteous, deeply cultivated, and intensely pious.

Rospigliosi was born into a distinguished merchant family on 27 January 1600. He was educated first in his native Pistoia, then with the Jesuits at the Roman Seminary. In 1619 he embarked on philosophy, theology and law at the University of Pisa, where he taught philosophy for a time before graduating in 1624.[3]

In that year he moved back to Rome to serve at the court of Francesco Barberini, who had been a fellow student at Pisa. Following the election of Francesco's uncle as Pope Urban VIII in the previous year, he had been called to Rome to fill the influential role of Cardinal Nephew. Rospigliosi accompanied Cardinal Francesco's legation to Madrid in 1626.

Rospigliosi also had close connections with the Pope's brother, Antonio Barberini the elder,[4] and with such powerful protectors his career progressed swiftly. In 1631 he became Secretary to the Congregation of Rites (the body charged with promoting uniformity in the rites of the Mass).[5] There followed a succession of appointments. In 1632 he became a canon of S. Maria Maggiore[6] and Referendary of the Apostolic Signatures (which dealt with petitions to the Pope). In 1635 he was made Secretary for Briefs to Princes, thus dealing with the international correspondence of the Pope, with whom in consequence he came into close and regular contact.[7] In 1642–3 he became Canonic Consultant, then Keeper of the Seal, to the Apostolic *Penitenzieria*,[8] and also vicar in the chapter of S. Maria Maggiore.[9]

By 1644 Rospigliosi had established himself in an influential position in the ecclesiastical hierarchy. A turning point came in the spring of that year when he received (along with the bishopric of Tarsus) the appointment of Papal Nuncio to Madrid. Relations with Spain were tense and Rospigliosi's task a delicate one; it was an honour which he seems not to have greeted with whole-hearted enthusiasm.[10] In the event, however, his departure for Spain proved timely. No sooner had he been presented to Philip IV of Spain than Urban VIII died. Under the Pamphili Pope, Innocent X, the Barberini were exiled and many of their circle disgraced. Rospigliosi, on the other hand, retained his post for a further nine years and was recalled from Spain only in 1653.

After a spell in Tuscany, Rospigliosi then returned to Rome to take up the post of Secretary of Latin Letters to the Pope.[11] His earlier allegiance to the Barberini seems to have been forgotten or forgiven. In 1654 he also served as Canon Prefect of the Cappella Liberiana of S. Maria Maggiore.[12] But, although Rospigliosi did not fall into disgrace under Innocent X, he never received the recognition which his talents merited.

For this he had to await the Pope's death in 1655. The College of Cardinals then immediately appointed him Governor of Rome and the new Pope, Alexander VII, made

Fig.5
After Giovanni Maria Morandi (1622–1717)
Portrait of Giulio Rospigliosi, 1666
Engraving by Nicolas Bonnart (c.1637–1718)
Bibliothèque Nationale, Paris
Bonnart's engraving appeared with an inscription which falsely attributed the original to Poussin. It is in fact taken from a portrait of Rospigliosi as cardinal by Morandi, of which a full-length version is in the Galleria Nazionale, Rome.

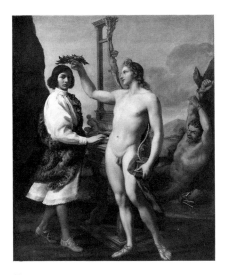

Fig.6
Andrea Sacchi (1599–1661)
Portrait of Marc'Antonio Pasqualini, late 1630s
Metropolitan Museum of Art, New York
Canvas 280.7 × 190.5 cm.
Pasqualini, a singer who performed roles in Rospigliosi's operas, is shown crowned by Apollo, with the vanquished Marsyas on the right. It seems likely, though it cannot be confirmed, that the picture was painted for Rospigliosi.

Above right: Fig.7
Final scene from 'Il Sant'Alessio'
Engraving by François Collignon
(c.1611–1671)
Bibliothèque Nationale, Paris
Collignon's engraving shows the 1634 performance of *Il Sant'Alessio* in the Barberini theatre. The final scene featured a celestial concert and a dance of Religion and the Beatitudes. The sets were designed by Francesco Buonamici.

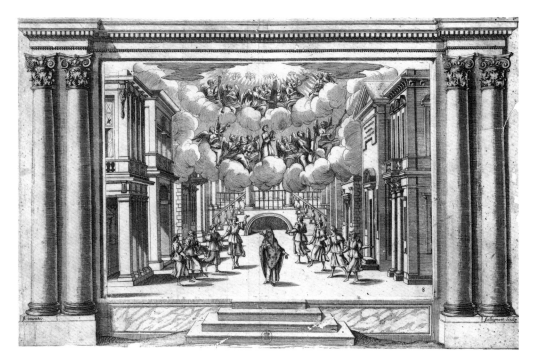

him Secretary of State. And in a further two years he was finally nominated a Cardinal. This model career was crowned by his election as Pope in 1667.

The Poet

Undoubtedly the favour extended to Rospigliosi at the Barberini court was influenced by his literary talents. He published a few poems and discourses in the 1620s,[13] notable among the latter being his commentary on Francesco Bracciolini's flattering allegorical poem *On the Election of Urban VIII*.[14] However, Rospigliosi's occasional writings have attracted little attention; it is in his activity as a librettist for opera that he made his most significant literary contribution.[15]

Rospigliosi's first libretto was that for *Il Sant'Alessio,* a sacred musical drama first performed in 1631, and revived for the inauguration of the new theatre of the Palazzo Barberini in the following year.[16] The music was provided by Stefano Landi and the sets were designed, at least in part, by Pietro da Cortona.[17] The soprano role of Alessio's wife was sung by Marc'Antonio Pasqualini (Fig.6). An expanded version was performed in 1634 with new sets, which are recorded in a series of engravings by François Collignon (Fig.7).[18] The opera tells the story of a young Roman nobleman who, disguised as a monk, lived unrecognised in his father's home, resisting the temptations offered by the Devil to reveal his identity and return to a life of luxury. The austere subject broke with the pastoral-mythological subject matter of Florentine opera and was presented with a new dramatic plausibility enlivened by a more complex musical structure – which relied less on recitative for the advancement of the plot – and by the introduction of realistic comic characters. The last are characteristic of Rospigliosi's *libretti* and reveal the influence of Spanish theatre, which he had encountered as a member of Francesco Barberini's legation to Spain in 1626.[19]

Three more of Rospigliosi's operas were based on the stories of early Christian saints: *I Santi Didimo e Teodora* (1635–6), *San Bonifatio* (1638–9), and *Il Sant'Eustachio* (1643), the first with music by an unknown composer, the others with music by Mazzocchi. The last two in particular were notable for their simplicity. Rospigliosi seems to have been looking for dramatic intensity rather than spectacular effects. This tendency was taken further in *La Genoinda,* performed in 1641 with music attributed to Mazzocchi, a tragedy set at the time of the crusades in which Genoinda, falsely accused of infidelity by her frustrated lover Gelone, is sentenced to death by the Prince, her husband, but survives and is discovered in the woods by assassins hired by Gelone to kill the Prince. The customary distractions from the main plot were almost entirely eradicated and the drama in consequence strengthened.

Rospigliosi also produced secular operas and in them showed himself more open to the contemporary Roman taste for large casts, multiple sub-plots, and spectacular sets and stage machines. These could compromise the dramatic integrity of an opera, as was probably the case with *Erminia sul Giordano* which was performed at the Barberini theatre in 1633, with music by Michelangelo Rossi and elaborate sets and stage machines by Andrea Camassei and Francesco Guitti (Fig.8). *Il Palazzo Incantato* (1642; music by Luigi Rossi) was another example, though less noted for its machines; the sets were designed by Andrea Sacchi. But the most remarkable of Rospigliosi's secular operas was *Chi soffre speri* first performed in 1637 and revived in altered form in 1639, the music by Mazzocchi and Marco Marazzoli.[20] *Chi soffre speri* is based on a tale from Boccaccio's *Decameron* and seems to be the first recorded comic opera. A notable member of the audience, at the 1639 performance, was John Milton.[21] The second *intermedio,* 'La Fiera di Farfa', was celebrated for its scenography by Bernini, judged especially life-like in its rendering of the bustle of the fair and the sunset with which the scene closed.[22]

Following his nunciature in Madrid, Rospigliosi produced a further four operas. These were all based on Spanish prototypes. *Dal male il bene,* written in collaboration with his nephew Giacomo, was performed at the Barberini theatre in 1654 and 1656 (music by Antonio Maria Abbatini and Marco Marazzoli). It was followed by *Gli Armi e gli Amori* and *La Vita Humana, ovvero Il Trionfo della Pietà* (see p.29), both performed in 1656 with music by Marazzoli. Last came *La Comica del Cielo,* which Rospigliosi had written in Spain, but which was not performed until 1668, when he was already Pope, with music by Abbatini. Besides *La Vita Humana,* which was an allegorical morality similar in conception to Spanish *autos sacramentales,* all these operas were based on Spanish plays. *La Vita Humana* had sets by Grimaldi recorded in engravings by G.F. Galestruzzi, which appeared in the published score.[23] The scenography for *La Comica del Cielo* was by Bernini.

Most of Rospigliosi's operas were staged with the sponsorship of the Barberini in the theatre of the Palazzo Barberini. Only *La Comica del Cielo* was actually staged by Rospigliosi himself in his own palace. His role was that of librettist and did not normally extend to commissioning the stage effects. However, his libretti defined both the dramatic development of an opera and the possibilities for scenographic embellishment. His most notable contribution to the development of opera was the introduction of realistic comic characters. But, for the author, these were of minor importance beside

Fig.8
Final scene from 'Erminia sul Giordano'
Anonymous engraving, 1637
Erminia sul Giordano was performed at the Barberini theatre in 1633 with sets by Andrea Camassei and spectacular stage machines by Francesco Guitti, engravings of which were published in 1637. The final scene included a cloud-borne Apollo accompanied by zephyrs who strewed flowers over dancing nymphs and shepherds.

Fig.9
Claude Gellée (1600–82)
Apollo and the Seasons dancing to the Music of Time
Pen and ink with white heightening and water-colour 18.9 × 26 cm.
Pallavicini Collection, Rome
The drawing, very probably from the collection of Giulio Rospigliosi, was made in preparation for Claude's etching (Fig.10).

Right: Fig.10
Claude Gellée (1600–82)
Apollo and the Seasons dancing to the Music of Time, 1662
Etching 18.2 × 25 cm.
Courtauld Institute of Art, London

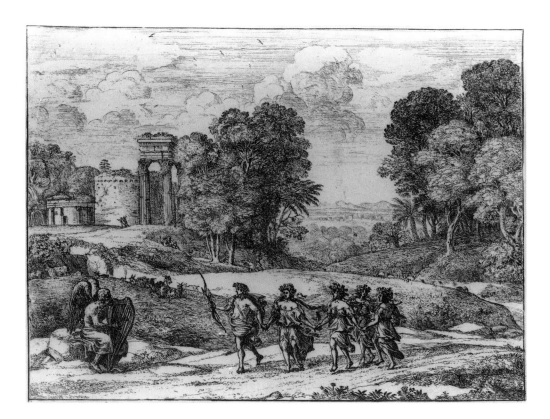

Fig.11
Claude Gellée (1600–82)
Landscape with Shepherds, c.1637
Canvas 49.7 × 39 cm.
Pallavicini Collection, Rome
Claude seems to have painted this small landscape to take the place of a similar picture (now in the National Gallery, London) which in spite of Rospigliosi's offers he would not part with.

the purpose of moral instruction. Even *Chi soffre speri* had its moral, an explanation of which was published separately.

Few of Rospigliosi's operas were without some allegorical component elucidating the moral lesson to be learned. This interest in allegory was not something which as a general rule carried over to Rospigliosi's art patronage. But it seems to play a particularly important part in his commission for *A Dance to the Music of Time*.

The Patron

In 1646 Rospigliosi identified three of the painters most highly esteemed in Rome as Pietro da Cortona, Andrea Sacchi and Poussin.[24] Their works could be obtained only by the exercise of great patience. In 1637, for instance, when he was trying to obtain a picture from Cortona for his brother Camillo, Rospigliosi advised Camillo to be patient rather than pressurise the artist and risk obtaining a work which would be merely ordinary.[25]

Presumably benefiting from the experience of his own literary endeavours, Rospigliosi's patronage of painters seems to have been peculiarly sympathetic and intelligent. This emerges in particular from the commission for *A Dance to the Music of Time*. But what can we say in more general terms about the scale and scope of Rospigliosi's patronage before he became Pope?

The subject has never been investigated in detail and is a difficult one in the absence of any contemporary account of Rospigliosi's collection. In 1713 an inventory was drawn up of the collection of his nephew and heir, Giovanni Battista Rospigliosi (1646–1722), and it can safely be assumed that many of the pictures in this inventory

come from Giulio Rospigliosi's collection.[26] On the other hand, we can seldom be certain in the case of any specific picture. The evidence on Rospigliosi's patronage is otherwise fragmentary and we must await the analysis of his correspondence (at present in progress)[27] before a detailed account will be possible.

The impression given by the inventory of 1713 is that Rospigliosi had been very active as a patron of contemporary Italian artists. Pietro da Cortona (who had provided the set designs for the 1632 performance of *Il Sant'Alessio)* is well represented in the inventory. Sacchi is less well represented, but it has been suggested very plausibly that his portrait of Marc'Antonio Pasqualini, datable to the late 1630s, was painted for Rospigliosi (Fig.6).[28] Pasqualini sang soprano roles in both *Il Sant'Alessio* and *Il Palazzo Incantato.*[29]

Numerous other Italian painters appear in the inventory and only a few will be mentioned here. Rospigliosi's portrait was painted as Cardinal by Giovanni Maria Morandi (cf. Fig.5),[30] and as Pope by Salvator Rosa[31] and Maratta (Fig.19).[32] An artist who seems to have enjoyed particular protection was Giacinto Gimignani, a fellow Pistoian, who owed many commissions to Rospigliosi's intervention.[33] But Rospigliosi also offered his protection to the Calabrese Gregorio Preti and to his more famous younger brother Mattia Preti, from whom he commissioned a *Liberation of Saint Peter,* probably *c.*1640.[34]

In the eighteenth century, the Rospigliosi collection was noted for its landscapes and this doubtless reflects another facet of Giulio Rospigliosi's taste. He seems to have befriended Claude who, in return for the 'good advice' he had always received, bequeathed to Rospigliosi two drawings of his choice.[35] According to an anecdote related by Baldinucci, Rospigliosi especially desired a small landscape by Claude painted from nature in the garden of the Villa Madama and offered to pay the artist as many doubloons as were required to cover the picture. This is probably the *Landscape with a Goatherd and Goats* in the National Gallery, London.[36] But Claude refused to part with it and provided Rospigliosi instead with a similar view, which is one of the Rospigliosi pictures which passed into the present Pallavicini collection, Rome (Fig.11).[37]

Rospigliosi acquired at least two further paintings by Claude and a number of drawings. *A Landscape with Brigands,* datable to 1638/9 (Fig.12), and *A Coast View with Mercury and Aglauros* of 1643 (Pallavicini Collection, Rome) were both painted for him. He also owned several drawings of which not the finest, but the most interesting in this context is *Apollo and the Seasons dancing to the Music of Time* (Fig.9), a composition which clearly owes its inspiration to Poussin's *Dance to the Music of Time.* This drawing seems to have been made in preparation for Claude's etching of 1662 (Fig.10) and the choice of subject perhaps owed something to Rospigliosi's 'good advice'.[38]

Rospigliosi's arrival in Rome from Pisa in 1624 at the age of twenty-four had coincided with that of Poussin from Paris at the age of thirty. It is not unlikely that the two men met in the later 1620s at the court of Francesco Barberini. Conceivably Rospigliosi then acquired the small *Putto with a Cornucopia,* still in the Pallavicini collection, which is now accepted by most scholars as an early work by Poussin (Fig.13).[39] It is possible that he also owned the *Parnassus* probably of *c.*1631–2, now in the Prado, Madrid, which was later engraved with a dedication to him.[40] The subject, in

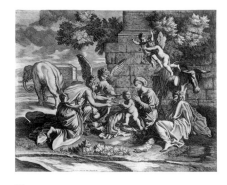

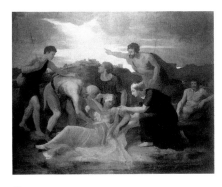

Fig.15
Nicolas Poussin (1594–1665)
The Finding of Queen Zenobia, late 1630s?
The Hermitage, St Petersburg
Canvas 156 × 194.4 cm.
The picture is unfinished and the attribution
to Poussin disputed. However, a picture
which seems to correspond was described in
the Rospigliosi inventory of 1713.

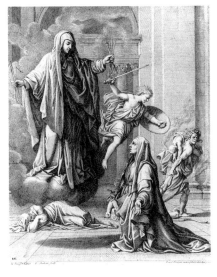

Fig.16
After Nicolas Poussin (1594–1665)
The Vision of S. Francesca Romana
Engraving by Gérard Audran (1640–1703)
Courtauld Institute of Art, London

which Apollo offers the cup of inspiration to a young poet, would have had an obvious appeal.

Rospigliosi seems to have been most active as a patron of Poussin in the second half of the 1630s. It is at this period that we can place the three 'moral poems' described by Bellori: *A Dance to the Music of Time* and *Time saving Truth* (Fig.3), which were almost certainly commissioned by Rospigliosi, and the *Arcadian Shepherds* (Fig.4), the case for which is less certain. A more conventional subject commissioned at the same period is the *Rest on the Flight into Egypt* (Fig.14)[41] which, though now lost, was seen by Charles Eastlake in a collection at Marseille in 1864 and described by him as 'an excellent and well preserved specimen'.[42] The inventory of 1713 also mentions four other pictures attributed to Poussin (not now identifiable) which may have been commissioned by Rospigliosi before his departure for Spain in 1644: a *Holy Family with SS. Anne and John the Baptist,*[43] two landscapes each with three figures,[44] and a *Virgin and Child in a Wood.*[45]

A more ambitious picture which could be another Rospigliosi commission of the same period is the *Finding of Queen Zenobia,* a large unfinished canvas in the Hermitage, St Petersburg (Fig.15).[46] This unusual subject is taken from the *Annals* of Tacitus. Zenobia, Queen of Iberia, unable on account of her pregnancy to follow her husband Rhadamistus in his flight from the invading Parthes, begs her husband to murder her. Rhadamistus stabs her and throws her into the river Araxes, whence she is recovered by shepherds and revived. It seems unlikely that Poussin would have delivered an unfinished picture to so important a patron. On the other hand the subject – of frustrated uxoricide – might be compared with Rospigliosi's libretto for *La Genoinda* performed in 1641 (see p.18). It seems possible that the canvas was abandoned when Poussin made the trip to Paris in 1640–2, that he found no time to return to it before Rospigliosi left for Spain in 1644, and that the patron later accepted it in its unfinished state.[47]

Curiously Rospigliosi seems to have acquired not only originals by Poussin, but also copies. The inventory of 1713 records both the original of *A Dance to the Music of Time,* and a copy.[48] These copies were probably destined for members of Rospigliosi's family in Pistoia to whom by 1637 he was sending crates of pictures.[49]

There seems to be no firm evidence of art patronage during Rospigliosi's years in Spain or in the period immediately following his return to Rome. Probably in 1656 or 1657 – which were plague years in Rome – he commissioned a further picture from Poussin, acquired as much as an aid to prayer, perhaps, as an addition to his collection. The subject was S. Francesca Romana praying to the Virgin, who appeared to her in a vision, to save Rome from plague.[50] The picture is lost, but known from engravings (Fig.16). In its startling severity, it must have compared with the celebrated *Annunciation* in the National Gallery, London.

We know more about Rospigliosi's patronage of Poussin and Claude than of Italian contemporaries. In consequence he may tend to emerge as having a more Francophile taste than was truly the case. Nevertheless, he was rare in being a patron of both Poussin and Claude. And his patronage of Poussin seems to have produced a few truly exceptional works. In *A Dance to the Music of Time,* particularly, he led the artist into a literary world of poetical philosophy – the world of his own poetry – and elicited a picture which is without parallel in the artist's *œuvre.*

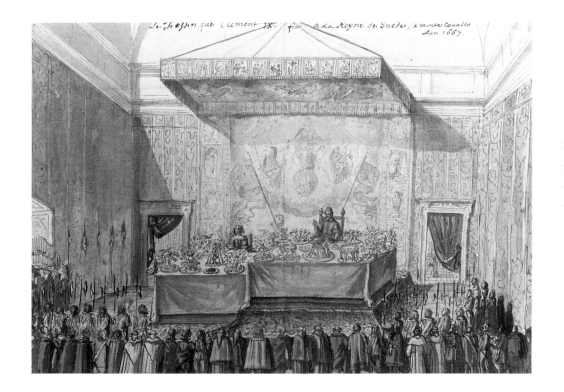

Fig. 17
Pierre Paul Sevin (1650–1710)
The Banquet given to Queen Christina of Sweden by Clement IX on 9 December 1668
Pen and ink with water-colour
24.8 × 37.6 cm.
Kungliga Biblioteket, Stockholm
Conversation between the Pope and his guest had to be conducted with the assistance of a go-between. The ladies were permitted to watch from behind the tapestries on the left. The Pope drank a strawberry and cherry cordial concocted to look like wine.

The Pope

On the death of Alexander VII, Rospigliosi, recommended by his diplomatic skills and political neutrality, was elected Pope. He took the name Clement IX. Extraordinarily, the election was supported by both Spain and France. It was greeted enthusiastically by the Curia and joyously celebrated in Rome and in Rospigliosi's native Pistoia.

When he took over the papacy, Rospigliosi's health was already failing and the chances of his tenure being a long one were slim. He made few major personnel changes and much that he achieved represented a continuation of policies pursued under Alexander VII. The major initiatives of his papacy were an attempt to settle the Jansenist question with France, resulting in the so-called Clementine Peace, and his (ultimately unsuccessful) campaign to defend the town of Candia in Crete against Turkish aggression. He instituted a series of reforms concerning the discipline and economic organisation of convents, the granting of indulgences and the authentication of relics, on the activities of missionaries, and abuses against the Jews in Rome. He also founded an Academy for the study of Church History.

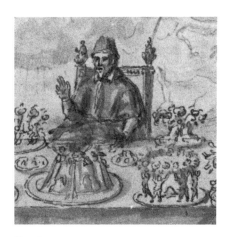

Fig. 18
Detail of Fig. 17
One of the sugar sculptures *(trionfi)* at the Pope's table seems to reveal a continuing interest in the round dance.

Clement IX has the reputation of breaking with the blatant nepotism of his predecessors. This may be an exaggeration since he found significant posts for his brother and nephews and seems at least to have tolerated, if he did not encourage, a certain syphoning of Vatican funds into family coffers.[51] Yet, by comparison with his predecessors, he extended only modest favours to his relatives.

The papacy was characterised by great generosity towards the homeless and the unemployed and this won Clement IX popularity with the Roman people. He reduced taxes, supported industry and promoted justice. The motto on one of the medals struck in his honour reads *Aliis non sibi Clemens* ('kind to others, not to self'). He visited the

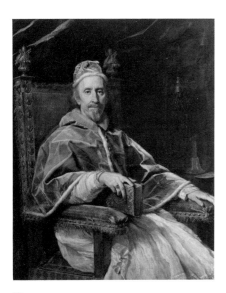

Fig.19
Carlo Maratta (1625–1713)
Portrait of Clement IX, 1669
Canvas 145 × 118 cm.
Pinacoteca Vaticana, Rome

sick and daily provided a meal at the Vatican for thirteen poor people on whom he waited himself. He personally heard confessions (on one occasion for three and a half hours) in a special confessional set up on his orders in St Peter's. At the same time he was frugal, strictly limiting the sums to be spent on his own table. And there is no doubt that he was deeply pious.

The Pope, however, was not without extravagance where the occasion merited it. He had a particular affection for the recently converted Queen Christina of Sweden and organised a spectacular banquet in her honour in 1668 (Fig.17).[52] During the carnival of 1668 he also staged a production of *La Comica del Cielo,* the opera he had written in Spain, characteristically ordering additional performances for the monks and nuns (separately) and for the Roman people.

The papacy lasted only one and a half years and, in consequence, Rospigliosi's official patronage was of limited importance. His major contributions to the embellishment of Rome were the completion of the colonnade of St Peter's and the angels commissioned from Bernini to stand on the Ponte Sant'Angelo. He commissioned the decoration of the chapel of S. Domenico in the church of S. Sabina with Borrominesque architecture and frescos by Ludovico Gimignani. And he pursued ambitious plans for the rebuilding of the Tribune of S. Maria Maggiore on lines scarcely less grandiose than the sumptuous Sistine and Pauline chapels constructed by his predecessors in the same church, but the project was never realised as planned.

There were many other projects associated with his brief pontificate, but few are of great importance. When he died in 1669, his loss was deeply and sincerely mourned. His life had been richer perhaps in quality than in quantifiable achievement. In the history of the Popes his part is a small one. But, as has been increasingly realised in recent years, his contribution to the development of opera was crucial. And in the field of patronage there is no single work which so well pays tribute to his creative involvement as Poussin's *Dance to the Music of Time*.

Subject and Meaning

Fortunately, in their biographies of Poussin, both Bellori and Félibien explain the subject of *A Dance to the Music of Time* in some detail (see p.64). The four dancing figures represent Human Life, or rather the cycle of the human condition. In the background is Poverty, on the right Labour, in the foreground Wealth, and on the left Pleasure. The last was described by Bellori as Luxury, but Félibien calls her Pleasure and this, as we will see, is probably more correct. The implication of the round dance seems evident. Through Labour man acquires Wealth, Wealth permits Pleasure, and Pleasure indulged to excess ends in Poverty. And so the dance expresses a perpetual cycle.

Poussin seems to have drawn the symbolic attributes for his figures from what was then the standard reference work on visual symbols, the *Iconologia* of Cesare Ripa.[1] But he faced the problem of incorporating attributes sufficient to express his meaning without encumbering the dance. For Poverty he selected Ripa's description of *Povertà*, as invented by Doni,[2] a woman lying on dried branches, but he used the branches as a wreath on Poverty's head. The symbolism is at one level straight forward, since the poorest of Italian shepherds have been observed making their beds of dried branches even in quite recent times.[3] But, for Ripa, the dried branches carry the meaning of the incapacity of the destitute to be productive. Thus Poussin perhaps meant to distinguish unproductive poverty from productive labour. According to Bellori, on the other hand, the dry leaves signify lost possessions, and this would be equally appropriate since here poverty is also the effect of pleasure indulged. The fact that Poverty is male, while the other dancers are female, remains unexplained.

The figure of Labour, on the right of the group, is taken from Ripa's *Fatica Estiva* (Summer Labour),[4] and this explains the perplexity of those in the eighteenth century who thought she represented Winter (see p.65 below). Ripa proposes a sturdy, young woman in a light, short dress with bare arms, holding a scythe and flail, and accompanied by a bull. Nobody, of course, would recommend the introduction of such a figure into a round dance. Poussin represents Labour simply as a muscular young woman, with bare arms and shoulders. And, following Ripa's suggestion, he expresses in her pose and the turn of her head a sense of her bodily fatigue.

Ripa describes Wealth as a woman in rich garments decked with jewels holding a crown and a sceptre, with a golden vase at her feet.[5] Again Poussin retains only the attributes of dress, showing the figure with pearls in her hair, with white and gold draperies, and an arm-band of gold and pearls.

The identity of the fourth dancer remained for a time mysterious. Bellori called her Luxury, but there seems to be no description of Luxury in the editions of Ripa which

A Dance to the Music of Time
Detail of *putto* blowing bubbles

24

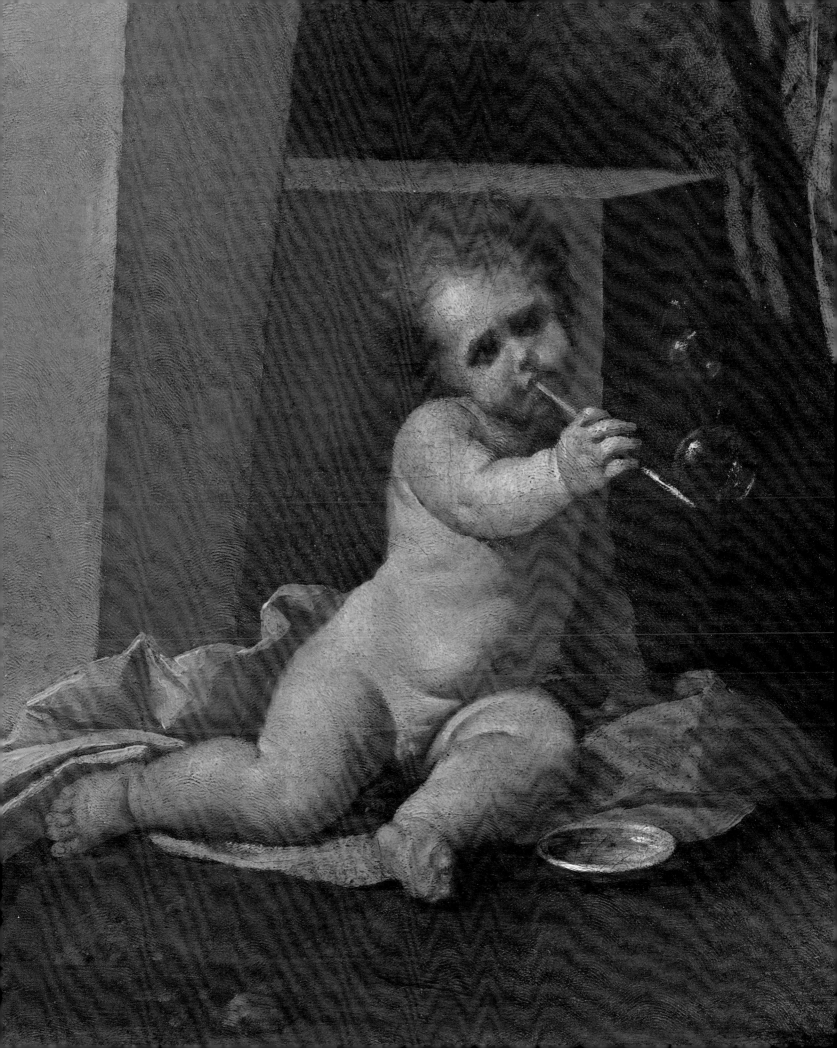

Poussin could have consulted. Félibien, on the other hand, describes her as Pleasure and her crown of roses is almost certainly taken from Ripa's *Piacere,* Poussin again ignoring the other attributes.[6]

At an earlier stage in the evolution of the composition, recorded in the drawing at Edinburgh (Fig.33), Poussin had given this last figure a peacock head-dress. It seems possible that he intended at first to show Luxury, and this could explain Bellori's confusion.[7] On the other hand, the peacock is also an attribute both of Pride and Prodigality, either of which would have been appropriate.[8]

Poussin derived only the main symbolic attributes from Ripa, and still needed to characterise the figures in terms of dress, pose and facial expression. Thus Poverty and Labour go barefoot while Wealth and Pleasure wear sandals of gold and white respectively. Pleasure is dressed in the primary colours blue and red, while Wealth is in gold and silver. Poverty and Labour are in earthier colours. The latter's dull brick-red is daringly close in hue to the gold of Wealth, but lacks its lustre. The poses and facial expressions are also telling. Poverty gazes longingly at Labour, while Labour strains to catch a glimpse of Wealth. Wealth seems to disdain the hand of Labour, and her own self-conscious dignity contrasts with the glowing face of Pleasure. This last suggests a rather wild hedonism reminiscent of certain figures in Poussin's earlier bacchanals.

Besides the dancing figures, Poussin introduced several references to the passage of time, to the cyclical nature of its divisions, and also to the brevity and vanity of human life. The elderly, bearded, nude, winged figure of Time is easily recognisable. But it is very unusual to see him playing the lyre rather than wielding a scythe. Time is represented here not as the Reaper, nor as the Revealer of Truth, but as a cosmic power: the interpreter of the primordial harmony of the universe. He bears a resemblance, inevitable but perhaps not entirely coincidental, to Orpheus, whose role he in some sense usurps (cf. Fig.26).

The stone Term on the left has young and old heads looking forwards and backwards, an attribute of Janus, the God of gateways who knew the past and the future, and who presided over the cycle of the years, being commemorated in the first month of every one.

In the sky Poussin adds Apollo in his chariot, with Aurora and the Hours, as a symbol of the cycle of the day. Apollo holds the circle of the Zodiac while his chariot is driven by a winged figure (perhaps Lucifer, the morning star). Aurora, the Goddess of Dawn, hovers in front scattering flowers, and behind flutter the dancing Hours with their insect wings.

Finally there are the two children in the foreground, one blowing bubbles, the other contemplating an hour-glass. We need not be quite as literal as Ramdohr (see p.65) in seeing these as the children of the dancing women, amusing themselves for what would after all be a long – not to say infinite – wait. They introduce the notion of Vanitas. The bubbles, which burst in an instant, are a commonplace symbol of the vanity and brevity of life. The hour-glass is the usual attribute of Time, its finite stock of grains numbering the moments of human life.

With the help of Bellori, Félibien and Ripa, therefore, it is possible to interpret the allegory of *A Dance to the Music of Time* with reasonable confidence. Aware of the

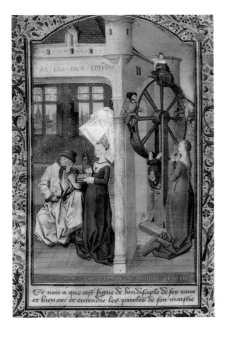

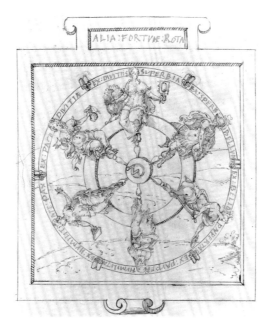

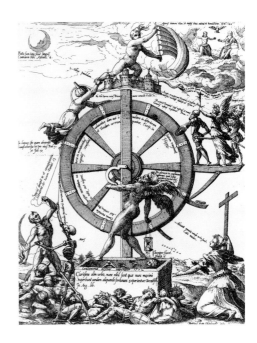

symbolism, we can begin to look at the picture with seventeenth-century eyes. It is what Bellori called a 'moral conceit expressed in painting' or, as he also calls it, a 'moral poem' (in this he is referring to the painting, not to anything written by Rospigliosi). The conceit seems to arise in the first place from a poetical-philosophical idea of long pedigree: the Wheel of Fortune.[9]

The Wheel of Fortune

In early Greek philosophy – in the Orphic mysteries – the notion of the wheel arises from a belief in the transmigration of souls. Since man is constantly born and reborn in varying states of happiness and destitution, his life may be likened to a great wheel constantly turning. In Roman art the wheel appears as an attribute of the goddess Fortuna. She stands on a wheel as a symbol of her fickleness: she may totter at any moment in one direction or the other. In a few Roman texts, and thereafter most notably in Boethius's *De Consolatione Philosophiae,* man is conceived as attached to the wheel, and Fortune turns it. Here Fortune is in control and may precipitate man from the top to the bottom, or from the bottom to the top, at her whim. Boethius's conception of the Wheel of Fortune is illustrated in an illuminated manuscript cutting in the Wallace Collection by the Maître de Coëtivy (Fig.20).

Doubtless as a matter of artistic convenience the men or women attached to the wheel often number four. In many medieval examples they are identified as *Regno, Regnavi, Sum sine Regno, Regnabo* (I rule, I have ruled, I am deprived on my Kingdom, I shall rule). In later elaborations the figures on the wheel may become more numerous and may express the conditions of man. Jean Cousin's *Livre de Fortune* expresses one such cyclical sequence: 'Out of Wealth, Pride; out of Pride, War; out of War, Poverty; out of Poverty, Humility; out of Humility, Peace; out of Peace, Wealth' (Fig.21). Then again the wheel might have seven occupants representing the seven ages of man, and this

in turn might suggest an association with the seven planets and the seven deadly sins.

As a visual symbol the Wheel of Fortune is essentially a medieval type. In the Renaissance the concept tends to survive in literature rather than in art. Thus in sixteenth-century French and English poetry we find references to Fortune's wheel. On occasion Fortune emerges as conducting a dance. Pierre Machault's *Danse aux Aveugles,* describes a dance presided over by blind Fortune, blind Love and blind Death. Alternatively the Wheel of Fortune may be turned by Time, as seen in a print by Martin Rota (Fig.22).[10] But as yet no clear source has emerged in earlier art or literature for *A Dance to the Music of Time* as conceived by Rospigliosi and Poussin. The picture takes the notion of the Wheel of Fortune, in particular the version which expresses a cycle of the condition of man, and presents it under a new poetic veil, more suited to its age.

The Cosmic Dance

In this respect *A Dance to the Music of Time* involves a coupling of the medieval image of the Wheel of Fortune with another idea of classical pedigree, that of the Cosmic Dance. By placing the cycle of human destiny within the context of the cycles of Time, Poussin (or Rospigliosi) evokes the ancient metaphor of the Harmony of the Spheres, that sweet music to which the heavenly bodies move as in a measured dance. The Harmony of the Spheres remained poetic currency in the seventeenth century. It was defended, for example, by Milton who, it will be remembered, was among the audience at Rospigliosi's *Chi soffre speri* in 1639.[11] The Cosmic Dance was taken as a metaphor not only for the revolutions of the heavenly spheres, but also for the cyclical subdivisions of Time, and for the natural order in general. As such it appeared with some regularity in Elizabethan poetry, the most notable example being a poem by Sir John Davies entitled *Orchestra,* which conceives every aspect of the natural order as displaying the character of a measured dance.[12] More relevant to Poussin would have been the image in Blaise de Vigenère's translation of the *Imagines* of Philostratus,[13] a book which he would certainly have known, which shows the Seasons dancing in a circle with the Hours above (Fig.24).[14]

In *A Dance to the Music of Time* the controlling influence is no longer the fickle goddess Fortuna, but Time himself. Time, who is here represented almost uniquely in art as an instrumentalist, sets in motion the Cosmic Dance. And part of this dance – inevitable, just as night follows day – is the rise and fall of the condition of man. Although the agency of man's actions – his labour or his dissipation – is required for the dance to continue, there is no choice. Labour is the inevitable consequence of Poverty, just as Poverty is the inevitable consequence of Pleasure. Hence the cycle of man's lot becomes a part of the grand system of creation.[15]

The Invention

The conception of *A Dance to the Music of Time* is erudite and this must owe much to the fact that Rospigliosi provided the subject. There is scarcely any evidence that Poussin himself was interested in moralising allegory, yet Rospigliosi's musical moralities and

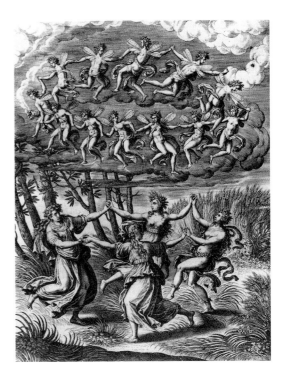

Right: Fig.23
Frontispiece to Athanasius Kircher, *Musurgia Universalis*, 1650
Kircher (1602–80) was one of the foremost theoreticians of music during the Baroque period. He benefited from Rospigliosi's patronage and probably knew Poussin. The frontispiece to his great musical treatise shows an allegorical figure of Music seated on the concentric celestial spheres. Just visible in the background are round dances on land and in the sea referring to the Cosmic Dance.

Far right: Fig.24
Dance of the Seasons and the Hours
Plate from Blaise de Vigenère's translation of the *Imagines* of Philostratus, 1614
A seventeenth-century French interpretation of the picture described by Philostratus in which the Seasons are shown dancing a round. The association of the round dance with the cyclical divisions of time seems to lie behind the conception of Poussin's painting.

operas were full of it. *La Vita Humana*, staged in 1656, may be taken as an example. The main action opened with a dialogue between Pleasure and Understanding, interrupted by the entrance of Human Life accompanied by Innocence and Guilt. Guilt forms a duet with Pleasure to tempt Human Life into wantonness, indolence, gluttony, avarice, pride, anger, and envy, while Understanding and Innocence counter with temperance, exercise and study, abstinence, liberality, humility, patience and disdain of worldly things. And so it goes on.

There appear to be no precise parallels between Poussin's painting and anything which is recorded of Rospigliosi's poetry or libretti. *La Vita Humana* had opened with the stage in near darkness and Aurora scattering scented flowers followed by Apollo, on whose arrival, by miraculous artifice, the whole theatre lit up. *I Santi Didimo e Teodora* had a scene in which Pleasure, Riches, Vanity and Idleness tempt Teodora. And another contemporary opera *Adrasto* (which has been attributed to Rospigliosi) had a prologue in which Time appeared with the Four Seasons along with Opportunity and Revenge.[16] But there seems no particular reason why an allegory devised for painting should have been repeated on the stage, or vice versa. There were after all dramatic possibilities on the stage which no painter could hope to imitate. When Time made his appearance in the final act of another opera of 1643, for example, he handed out pairs of spectacles to each of the characters on stage that they might better discern the truth.[17]

Nevertheless, the fact that the moral conceit of the picture is expressed in the form of a dance suggests a particular analogy with Rospigliosi's operas. The productions which appeared in the Barberini theatre were often interspersed with interludes of dance. A dance of Religion and the Eight Beatitudes appeared, for example, at the end of *Il Sant'Alessio* (Fig.7), and a dance of the seven Virtues at the end of *La Comica del Cielo. A Dance to the Music of Time* is in some sense the equivalent in painting of these operatic interludes.

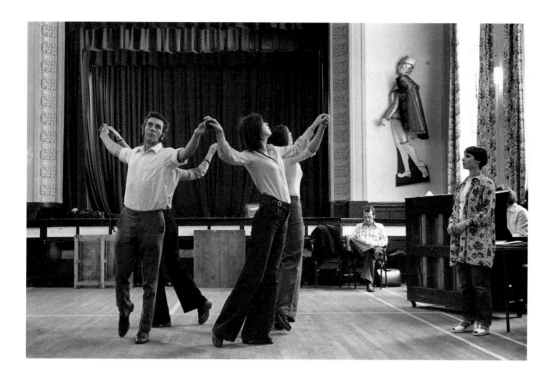

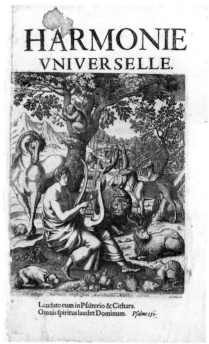

Coda

This may lead us to a further speculation about Rospigliosi's thoughts in commissioning the picture, though it is no more than conjecture. The emergence of opera in the seventeenth century – or at the very end of the sixteenth – was a product of theoretical speculations on the music of the ancients, and its relation to poetry and dance. In the first place poetry was deemed to have not only literal meaning, but meaning dependent on the sounds of words. Music too must have had these sound-meanings and, in the drama of the ancients, the sound-meanings of music and words must have been equivalent and mutually reinforcing. Moreover, since the poetry of the ancients scanned in regular patterns of long and short feet, it was clear that music and dance must have shared this same measure with poetry. Thus poetry, music and dance were united in their adherence to the same universal laws of harmony, and the practical outcome of this was the emergence of opera.

The union of the arts arose from and depended on the notion of universal laws of harmony. These laws were the subject of intensive study at precisely the time that *A Dance to the Music of Time* was painted. They were expounded in that massive treatise, Mersenne's *Harmonie Universelle,* which appeared in 1636 (Fig.26).[18] Mersenne did not apply his laws to the art of painting, but he did suggest that they were applicable to all the arts (and sciences), not only music and dance. At the same time, theorists of painting consulted classical writings on poetry and music not only because there was no real theory of painting to be derived from classical authors, but also because the theory of poetry and the theory of music were part of a universal law which must also be applicable to painting.

Engaged as he was in the union of poetry and music in opera, and being a vigorous and imaginative patron of painters, it is difficult to believe that Rospigliosi was not

Above left: Fig.25
Rehearsal for a production by Jonathan Miller of Monteverdi's *Orfeo,* 1976
Photograph by Fay Godwin
A Dance to the Music of Time was staged by Jonathan Miller in 1976, and thus reverted to the format which may have inspired it in the first place.

Above right: Fig.26
Frontispiece to Marin de Mersenne, *Harmonie Universelle,* 1636
Mersenne's treatise on Universal Harmony must be roughly contemporary with *A Dance to the Music of Time.* It sought to define the laws of harmony in music and dance, but suggested that these laws applied also to the other arts (and sciences), including painting. The frontispiece reproduces a classical relief in the Mattei collection which was probably known to Poussin. This or another antique image of Orpheus may have provided the source for Poussin's figure of Time.

interested in such questions. Indeed, in 1642, he devised a prologue to *Il Palazzo Incantato* in which he put on stage four sopranos: Painting, Music, Poetry and Magic. It is pure conjecture, but *A Dance to the Music of Time* could obviously be seen as a corollary in which Music, Poetry and Dance were brought together not on stage, but in Painting.[19]

Evolution of the Composition

We have no record of Poussin's thoughts as he was working on *A Dance to the Music of Time*, but some idea of his intentions can be gathered by comparing the final solution of the painting with that proposed in the preparatory drawing in the National Gallery of Scotland, Edinburgh. To this we can add the evidence of the painting itself. The preparation of the canvas is unusual, and this might suggest that Poussin was attempting something new. There are also changes which took place as the artist was working on the canvas, which can be seen either with the naked eye, as *pentimenti,* or by X-radiography.

The Edinburgh sheet is one of Poussin's most appealing drawings (Fig.33). It is also our only evidence of the artist's intentions before he started work on the canvas. At this stage the composition was already substantially resolved and it seems likely that Poussin had made other preliminary sketches. But, if any of these survive, none has yet come to light.[1]

The setting for the dance was built up from elements which Poussin had used elsewhere. The double-headed term on the left and the oblong block of stone behind it (which in the drawing looks like a sarcophagus), together with the palm tree and the pedestal on the right had all been used previously in the *Putti with a Chariot and Goats,* now in the Palazzo Barberini, Rome (Fig.27), an immature work painted probably about ten years earlier.

In the drawing the chariot of Apollo dramatically dominates the sky, accompanied by the morning star (symbolised by a *putto* holding a torch) and preceded, on the far right, by the figure of Aurora with one arm stretched before her. This group is close in conception to one which appears in the *Diana and Endymion* of c.1630 (Fig.28). The more subdued group in the final painting might also be compared with that in the *Kingdom of Flora* of 1631 (Fig.29) from which the *putto* blowing bubbles in the bottom right-hand corner of the drawing was also taken. The figure of Flora could also be seen as a prototype for the dancers in the Wallace Collection painting.

The dance itself bears some relationship to the group which appears in the *Bacchanal before a Herm* in the National Gallery, London, of c.1633 (Fig.30), and which recurs, reversed, in the *Adoration of the Golden Calf* in the same collection probably of 1634/5 (Fig.31).[2] In both pictures Poussin had tackled the problem of constructing an animated dance in a manner which creates a sense of movement in depth while maintaining an ordered pattern in the two-dimensional plane. However, the earlier dances were both revels, one Priapic, the other idolatrous. Although the dance in the Edinburgh drawing retains something of the same mood of energy and abandon, it is already more

Fig. 27
Nicolas Poussin (1594–1665)
*Putti with a Chariot and Goats, c.*1626
Tempera on canvas 74.5×85.5 cm.
Palazzo Barberini, Rome
The Term, palm tree and pedestal in the drawing for *A Dance to the Music of Time* (Fig.33) seem to be taken from this immature work of probably some ten years earlier.

Opposite: *A Dance to the Music of Time*
Detail of Apollo and the Hours

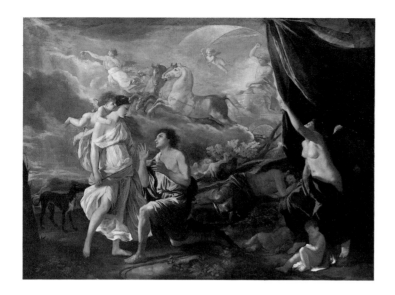 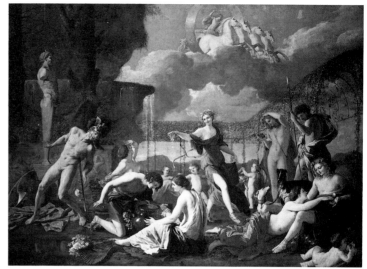

controlled, and this development is taken considerably further in the painting.

In devising *A Dance to the Music of Time,* therefore, Poussin worked with ideas he had used before, some of them several years earlier. These were recombined and further developed to create an entirely new image. The process was one in which Poussin referred not only to his own earlier works, but also to the works of other artists, but that question will be discussed separately below.

When he turned his attention from the drawing to the canvas Poussin made one particularly intriguing decision. The canvas seems to be prepared with a pinkish-red ground rather than the brown ground which was usual in the works of Poussin's early Roman period (1624–40).[3] And the ground is textured with thumb prints, which must have been gently pressed into it before it was fully dry. These thumb prints cover the whole surface evenly (Fig. 32). In a few areas, where the paint layers are thicker, they are scarcely discernible, but over most of the surface they remain evident. The finger-print branch of Scotland Yard investigated this phenomenon in 1976, and it is to Commander G.T.C. Lambourne that we owe the information that the prints were made probably with a left thumb. While it is possible that Poussin consigned this task to an assistant, it nevertheless seems more likely that the prints are his own.

Isolated finger or thumb prints are not uncommon in paintings of the period either in the ground, the priming or the paint layers. Nor is it especially surprising that an artist should use his hands in settling the ground into the canvas weave. But thumb or finger prints seem to be rare in Poussin's work. Examples are possibly faintly discernible in the *Saving of the Infant Pyrrhus* in the Louvre of 1634, but *A Dance to the Music of Time* seems to be unique in two respects: firstly in the methodical application of the thumb prints, one next to another, over the whole surface and, secondly, in the fact that the texture remains so clearly visible in the finished picture.

We cannot be certain whether Poussin intended these prints to have any consequence for the appearance of the picture. He used a relatively fine canvas with the result that the canvas texture is not evident in the picture surface. This would have permitted a more meticulous technique in the rendering of detail. But did Poussin wish

Above left: Fig. 28
Nicolas Poussin (1594–1665)
*Diana and Endymion, c.*1630
Canvas 121 × 168 cm.
Detroit Institute of Arts
Apollo's chariot has a proximity and presence which compares with the drawing for *A Dance to the Music of Time.*

Above right: Fig. 29
Nicolas Poussin (1594–1665)
The Kingdom of Flora, 1631
Canvas 131 × 181 cm.
Gemäldegalerie, Dresden
The Dresden picture provides a prototype for *A Dance to the Music of Time* in three respects: Apollo's chariot is similar, the figure of Flora in the centre compares with the dancers, and the *putto* blowing bubbles in the bottom right corner is repeated in the Edinburgh drawing (Fig. 33).

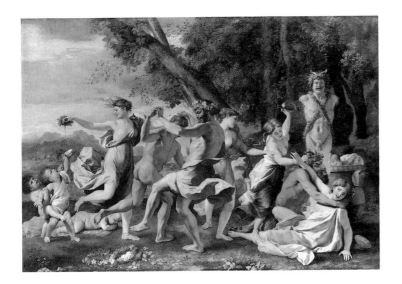

Above left: Fig.30
Nicolas Poussin (1594–1665)
Bacchanal before a Herm, c.1633
Canvas 104×142.5 cm.
National Gallery, London

Above right: Fig.31
Nicolas Poussin (1594–1665)
Adoration of the Golden Calf, 1634/5
Canvas 154×214 cm.
National Gallery, London

The dancing group is adapted (in reverse) from the *Bacchanal before a Herm*. Poussin was experimenting in the early 1630s with the problem of presenting a dance which creates a sense of depth while maintaining geometric structure in the two-dimensional plane. *A Dance to the Music of Time* represents his final solution.

to achieve a compromise in which a subtle texture would allow him to work more precisely, while not sacrificing the softness of light and form which a slightly textured surface imparts? This is a matter for conjecture, but it would seem consistent with the stylistic development which takes place between the drawing and the painting.

Comparing the painting and the drawing the most obvious change is the removal of Apollo's chariot to a greater distance. The Sun God no longer surges through, but glides over the landscape. In the drawing, the figure of Apollo with outstretched arms recalls the Renaissance image of the human form circumscribed by a circle. But the idea of combining this pose with the action of holding the horses' reins is an uncomfortable one, which Poussin abandons. In the painting the circle of the zodiac is reduced to a simple hoop which frames Apollo's form. As can be seen from the X-ray, this hoop was originally somewhat smaller (Fig.34).

In the drawing the *putto* with a torch, representing the morning star, is placed behind Apollo. This is illogical and the figure is abandoned in the painting. However, since Apollo no longer holds the reins, Poussin is obliged to include the unusual motif of a winged figure driving his chariot. This is perhaps intended for the morning star.

The sweep of dancing Hours in Apollo's wake is much reduced in the finished picture, but an intermediate stage is apparent in the X-ray (Fig.34). In the drawing the Hours extend almost to the left edge of the composition; in the painting they are tightly grouped behind Apollo. In the X-ray we see a different group of Hours already reduced in scale, but extending further to the left. The figures are 'in reserve', which is to say that Poussin has painted around the outlines without actually working the figures up. It is clear that the tree on the left was not intended at this stage.

Apollo is dominant in the drawing not only in his physical form, but also in the hot midday light which irradiates the whole composition. This Poussin transformed completely in the finished picture, replacing the light of midday with that of dawn. The character of the light perhaps determined Poussin's use of a pinkish-red rather than a brown ground. The dawn light which he introduces has a subtle pinkish or purplish cast, as is evident in the delicate mauve and violet hues used for the pedestal on the right.

Fig. 32
A Dance to the Music of Time
Detail in raking light
Astrid Athen, National Gallery, London
A raking-light photograph clearly reveals the
texturing of the ground with thumb prints.

The light has become cooler and the flickering highlights and deep shadows of the drawing are abandoned in favour of a more even tone.

It is this transformation of the light which most affects the mood of the finished picture. However, Poussin also rethought the dancing group, replacing the sensuous gaiety of the drawing with a measured calm. The drawing shows slender nymphs, their sinuous contours revealed by their diaphanous draperies. In the painting the forms are more solid and the draperies fuller.

The X-ray shows that this development took place in part while Poussin was working on the canvas. Thus in the X-ray we see the original profile of the figure of Pleasure on the left, in reserve (Fig. 35). At this stage the blue drapery was tucked in closer to Pleasure's waist at the back, and it clung to her body at the front, down to the level of the thigh. Later the blue mantle was shortened and extended to the left at stomach level. The lower portion of the original blue garment has become visible as a pentiment. The X-ray shows a similar alteration to the figure of Poverty whose green

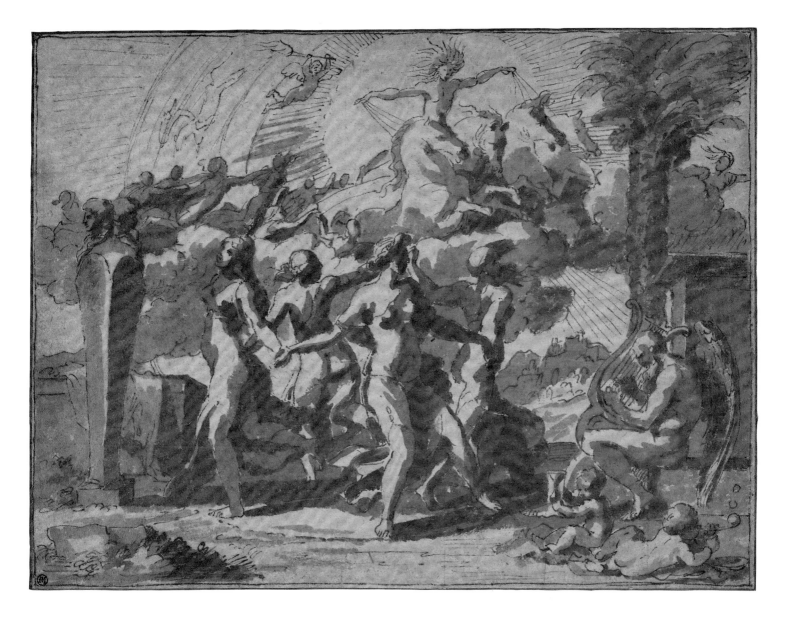

Fig. 33
Nicolas Poussin (1594–1665)
A Dance to the Music of Time
Pen and wash drawing 14.8 × 19.8 cm.
National Gallery of Scotland, Edinburgh
The drawing is our only source for Poussin's
thoughts before he started work on the
canvas. It reveals major differences not only
of detail, but also of mood.

drapery now extends further to the left, both above and below the waist. And the figure of Labour was also originally closer to the drawing, her draperies billowing out at the level of the thigh rather than the waist (Fig. 36).

The changes introduced by Poussin when he transferred the dancing group to canvas, and the alterations he made when he was working on the canvas, result in figures which are weightier and a dance which is more ponderous. At the same time Poussin introduced a greater geometric rigidity to the dancing group. Already in the drawing the figure of Wealth had formed a central axis. This was further stressed in the painting by the alignment of Apollo above her on the same axis. Poussin also lowered her arms such that they now form the top of an isosceles triangle whose base is the bottom edge of the picture. He also brought the right leg of Poverty and the left arm of Pleasure into alignment. The group is thus brought into a structural harmony which contributes to a sense of permanence and timelessness. The result undermines in some degree the sense of movement in the drawing and there is a tension in the finished painting between the

37

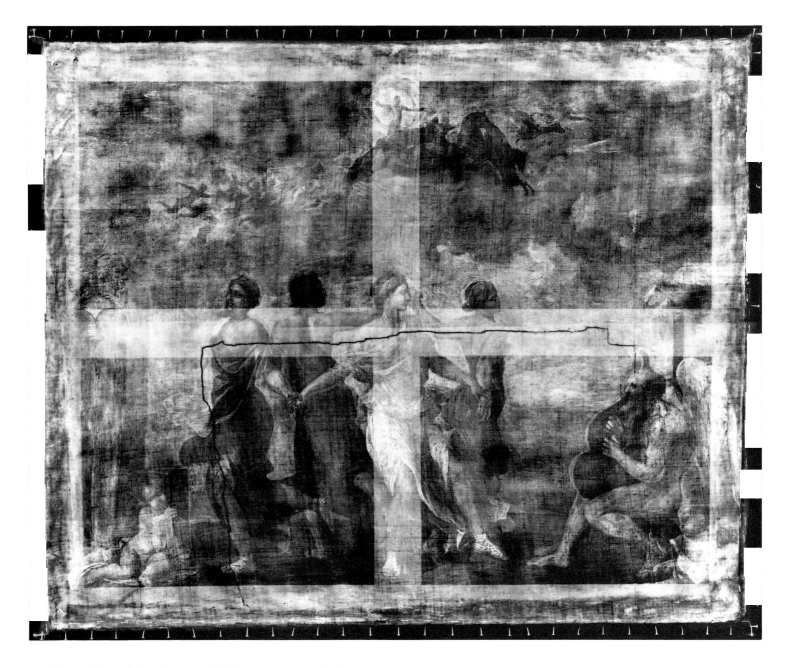

implied activity of the figures and their apparent equipoise.

A few other changes between the drawing and the painting are worth noting. The head of Time was brought into an upright position perhaps partly to compensate for the omission of the vertical accent of the palm tree. The effect is also to engage the figure with the dancing group. Two new trees were introduced, a slender birch on the left which occupies the area of sky vacated by the Hours, and a small tree in the middle distance on the right. This, as a pentiment shows, was originally larger and by implication closer to the spectator. In addition the pair of *putti* was split and both the figures redrawn, by reference, as will be discussed below, to models by Duquesnoy.

There is a recurrent theme to these changes. Throughout Poussin abandons the heart for the mind: sensuousness is sacrificed for monumentality, movement for measure, drama for restraint, rhythm for geometry, the heat of midday for the coolness of dawn.

Fig. 34
A Dance to the Music of Time
X-radiograph
Astrid Athen, National Gallery, London
Showing a large L-shaped tear, probably of the eighteenth century.

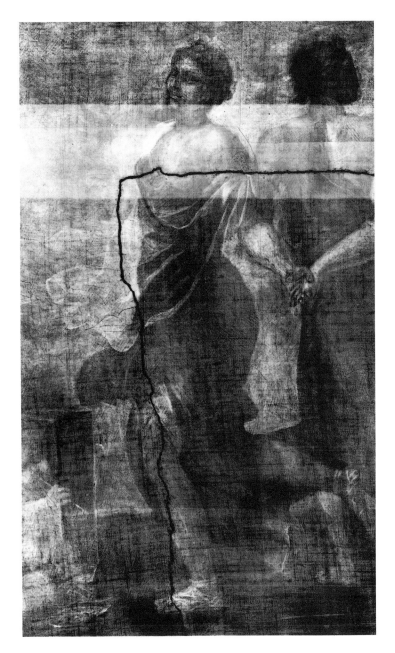

Above left: Fig.35
Detail of Fig.34
Poussin originally conceived the figure of Pleasure as a sensuous form, closer to that in the drawing. As he was working on the canvas he made her draperies fuller.

Above right: Fig.36
Detail of Fig.34
The figure of Labour was changed. The draperies now billow out at the level of the waist rather than the thigh.

The evolution of the picture encapsulates much of what we suppose to be Poussin's development over the course of the 1630s.

Finally, this raises the question of how to place the picture in Poussin's chronology. If we had only the drawing, we would surely associate it with the *Diana and Endymion* (Fig.28) and the *Kingdom of Flora* (Fig.29) and suggest a date in the early 1630s. Yet the finished painting has a measured lucidity which seems to set it apart from other works of that period. We thus have a paradox. Either Poussin returned at the end of the 1630s to ideas and motifs which were characteristic of his work in the early years of the decade; or the subject and the commission inspired him at this earlier time to something which was largely new.[4]

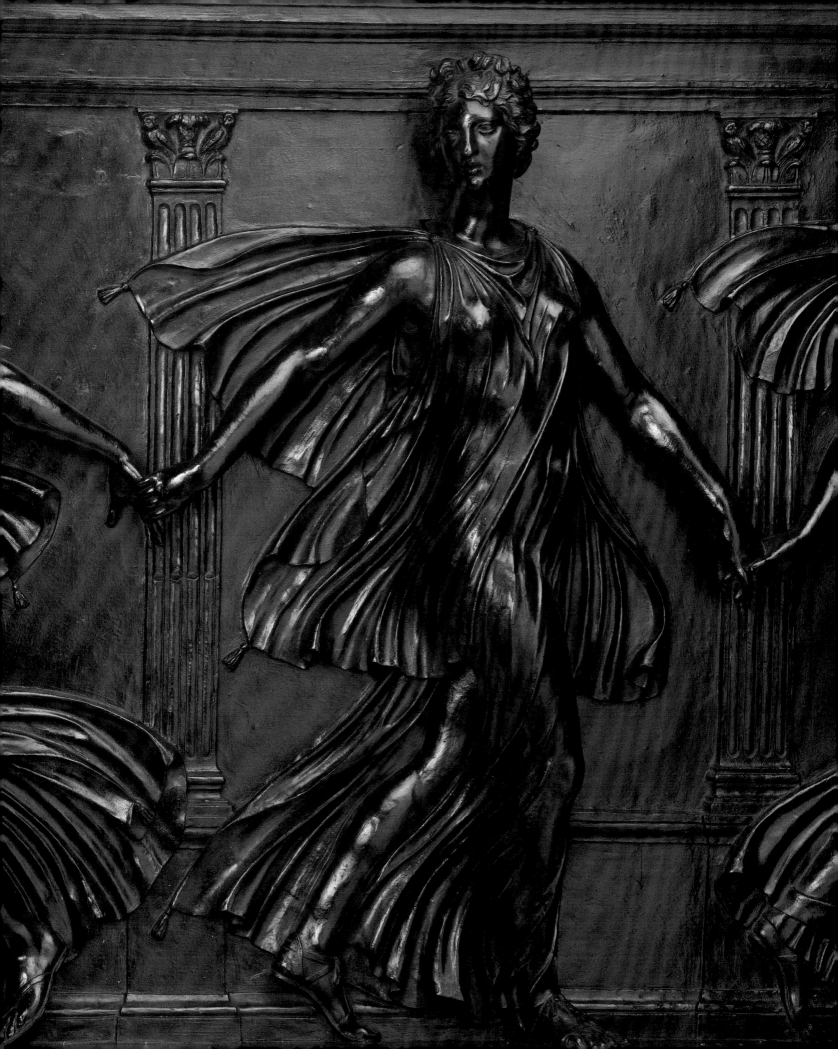

Visual Sources

Opposite: Detail of Fig.47, bronze relief of
the Borghese Dancers

Below left: Fig.37
The Infant Bacchus
Bronze statuette
French, mid-eighteenth century
Height 24.2 cm. length 29.3 cm.
The Wallace Collection, London (s199)

Below right: Fig.38
Cupid with his Bow and Arrows
Bronze statuette
French, mid-eighteenth century
Height 24.7 cm. length 28 cm.
The Wallace Collection, London (s198)

A Dance to the Music of Time is an erudite picture. The subject provided by Rospigliosi is a learned literary conceit, as we have discussed. But the picture also displays a certain visual erudition. The image is conceived with reference to antique and Renaissance sources. And in one instance Poussin seems also to have made use of works by his friend and contemporary, the Flemish sculptor François Duquesnoy.

Poussin and Duquesnoy

As Jennifer Montagu has observed, the two *putti* in *A Dance to the Music of Time* bear a striking resemblance to two lost statuettes by François Duquesnoy (1594–1643).[1] Duquesnoy's originals also provided the source for two pairs of eighteenth-century French bronzes in the Wallace Collection, the finer of which is included in the present special display (Figs.37, 38).[2] (The other pair can be seen on the mantelpiece in gallery 18.[3])

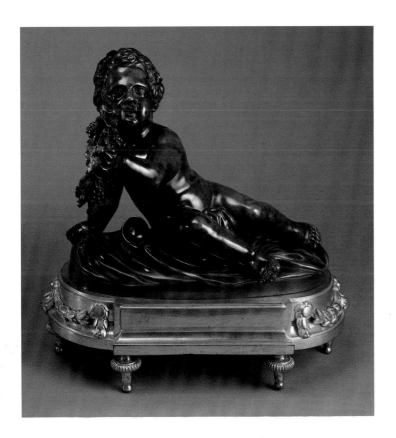

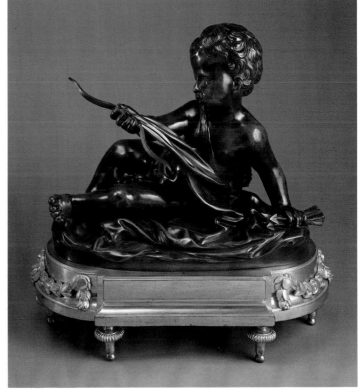

Poussin and Duquesnoy were friends. In 1626 they were sharing lodgings in the Via Paolina.[4] According to Bellori they jointly studied the *Feast of Venus* by Titian in the Villa Aldobrandini (now in the Prado, Madrid), Poussin producing not only paintings in oil and gouache, but also clay reliefs. Poussin's two bacchanals of *putti* in the Palazzo Barberini, of which one has already been mentioned (Fig.27), are generally thought to be products of this study.[5] Poussin also used Duquesnoy's reliefs as models for his own paintings, as can be seen in the case of the pair of *putti* representing sacred and profane love in the *Mars and Venus* in the Dulwich Picture Gallery, London, which are taken from a relief by Duquesnoy in the Galleria Doria Pamphilj, Rome.[6]

Duquesnoy was renowned for his statuettes of *putti,* a number of which, some in terra-cotta, others in bronze, came into the possession of the French sculptor François Girardon (1628–1715). They are illustrated in a set of engravings which Girardon had made of his collection, produced by the engraver Chevallier from drawings by Girardon's pupil René Charpentier. None of the original models is known to survive, nor do there seem to be any surviving examples in bronze which can be ascribed to Duquesnoy himself.

In the drawing for *A Dance to the Music of Time* in Edinburgh (Fig.33), the *putto* blowing bubbles seems to derive from one of Duquesnoy's models. However, the figure had already been used by Poussin in the *Kingdom of Flora* (Fig.29). When Poussin separated the *putti* and redrew them, he turned to new Duquesnoy models.

In the painting the connection with Duquesnoy is closest in the *putto* holding an hour-glass. The related statuette by Duquesnoy is seen (in reverse) in the fourth plate of the *Galerie de Girardon* where it is shown in front and back views, flanking a figure of Christ at the column (Fig.41). The *putto* here holds a crown of thorns and in the Wallace Collection bronze has been converted by the addition of a bow and arrows to serve as a Cupid (Fig.38). Nevertheless, the pose is in all essential respects the same.

The case of the second *putto* is a little less certain. The Duquesnoy model shows an infant with his hand to his mouth and his leg dangling over a rock (Fig.40). The engraving is again reversed and the *putto* appears in the correct sense in a Sèvres model for biscuit porcelain (Fig.39).[7] This figure would seem to be the source for the second of the two Wallace Collection bronzes (Fig.37). Again Duquesnoy's original has been

Fig.39
Model for a figure of Sèvres biscuit porcelain.

Below left: Fig.40
Detail from plate III of the *Galerie de Girardon*
Engraving by Chevallier after René Charpentier
The sculpture collection of François Girardon, engraved in the first decade of the eighteenth century, included several *putti* by Duquesnoy. The *putto* sitting on a rock, reversed in the engraving, is possibly the source for Poussin's *putto* blowing bubbles.

Below right: Fig.41
Detail from Plate IV of the *Galerie de Girardon*
Engraving by Chevallier after René Charpentier
The *putto*, seen in front and back views and reversed, seems to be the source for the *putto* with an hour-glass in *A Dance to the Music of Time.*

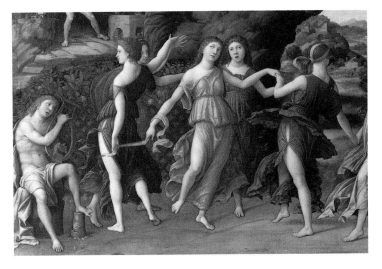

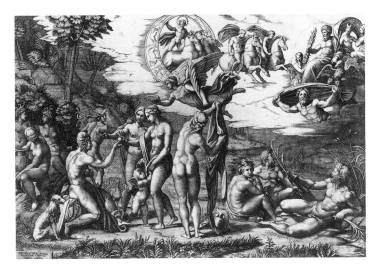

Above left: Fig.42
Andrea Mantegna (c.1430/1–1506)
Parnassus, c.1497 (detail)
Musée du Louvre, Paris
It is not certain that Poussin had seen
Mantegna's *Parnassus* in the original, but he
perhaps had access to a copy.

Above right: Fig.43
After Raphael (1483–1520)
The Judgement of Paris, c.1514–18
Engraving by Marcantonio Raimondi
(c.1480–1527/34)
Marcantonio's engraving seems to be the
source for the figure of Apollo in *A Dance to
the Music of Time*.

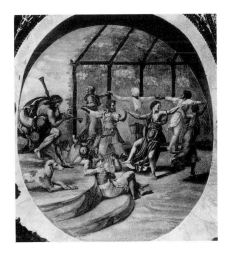

Fig.44
Giulio Romano (1499?–1546)
The Goat *(Haedes)*, c.1527–9
Fresco in the *sala dei venti* of the Palazzo del
Tè, Mantua executed to Giulio Romano's
design by Rinaldo Mantovano. Gombrich
proposed this image as the source for *A
Dance to the Music of Time*.

reversed and the bronze *putto* has new attributes, an empty cup and a vine branch, and
the positioning of the legs and head have been slightly altered. The *putto* in the bottom
left-hand corner of *A Dance to the Music of Time* is not identical to Duquesnoy's original,
but there is a striking similarity. The connection would be still closer if, as Jennifer
Montagu suggests, this is the *putto* used by Duquesnoy for the silver inkstand of
Constable Filippo Colonna, where he was blowing bubbles.[8]

Possible painted and engraved sources

The circular dance with its accompaniment on the lyre by a single seated figure suggests
the influence of Mantegna's *Parnassus* (Fig.42). The picture belonged to that celebrated
series painted by Mantegna, Costa and Perugino for the *studiolo* of Isabella d'Este in the
Ducal palace at Mantua, where it remained until it was acquired by Cardinal Richelieu,
along with other pictures from the *studiolo*, in 1627/9. It is not certain that Poussin saw
the picture, but he perhaps knew the composition through copies, and four of the
dancing figures were reproducing in an engraving after a preliminary drawing by
Mantegna.[9]

Certainly Mantegna's *Parnassus* would have had a particular interest for Poussin in
the mid 1630s. In 1635 he received the commission from Richelieu for a series of
Triumphs to complete a decorative cycle at the château de Richelieu which included five
of the pictures from the *studiolo*, the *Parnassus* among them. The detail from the *Parnassus*
illustrated in Fig.42 seems to offer a plausible source for Poussin's composition.

The figure of Apollo within the circle of the Zodiac seems to be taken from
Marcantonio Raimondi's engraving of the *Judgement of Paris* after Raphael (Fig.43). It is
also possible that Poussin looked at the works of Raphael's pupil Giulio Romano. The
roundel of *The Goat (Haedes)* in the *sala dei venti* of the Palazzo del Tè at Mantua has been
suggested as a possible source for *A Dance to the Music of Time* (Fig.44).[10] There is also a
related composition on the ceiling of the *loggia della grotta* in the same palace.[11] But
Giulio Romano would certainly have known Mantegna's *Parnassus*, so these works may
simply derive from the same source.

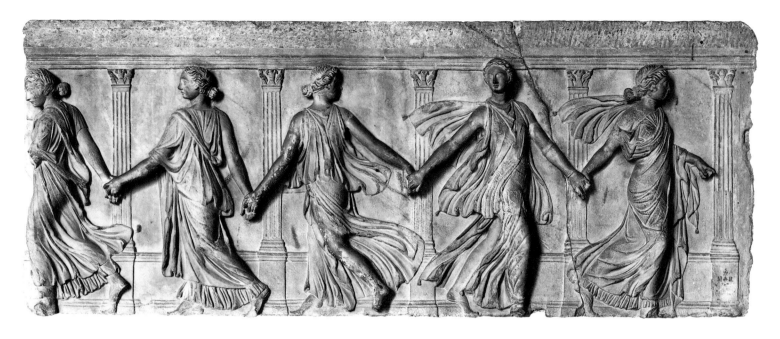

The Borghese Dancers

The marble relief in the Louvre known as the *Borghese Dancers* is now thought to be a
neo-Attic work produced in Rome in the first century B.C. or the first century A.D. It
is no longer greatly admired and is consigned to the Louvre reserves (Fig.45). In the
seventeenth century, however, the relief was counted among the most remarkable
examples of antique sculpture to be seen in Rome and its reputation remained high in
the eighteenth century, when Winckelmann described it as the most perfect example of
its type.[12]

There is no record of when the relief was excavated. It was certainly known from
the early sixteenth century when the figures were repeated in stucco in the *loggie* of the
Vatican.[13] And it seems not unlikely that Mantegna knew the relief when he painted the
*Parnassus, c.*1497 (Fig.42).[14]

At some time early in the seventeenth century the marble was acquired by Scipione
Borghese, nephew of Pope Paul V. It was perhaps in Borghese's hands by 1614 when it
was clearly the inspiration behind Guido Reni's treatment of the Horae in his famous
ceiling painting of *Aurora* in the garden *loggia* of Borghese's newly constructed palace on

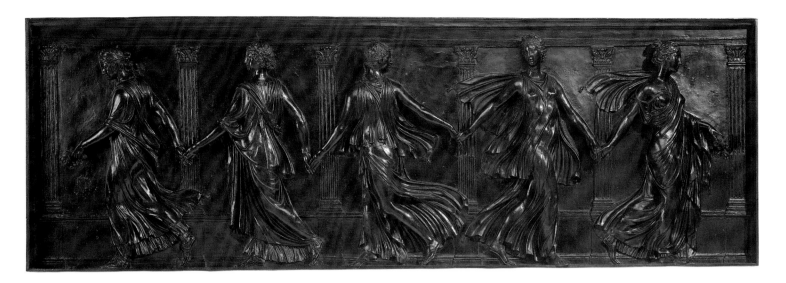

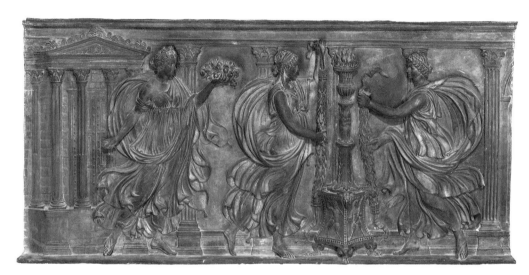

Above: Fig.47
François Anguier (1604–1669) and Henri Perlan (1597–1656)
The Borghese Dancers
Bronze relief after an antique original
Height 66.6 cm. length 200.8 cm.
The Wallace Collection, London (s155)
The bronze cast of the *Borghese Dancers* in the Wallace Collection seems to have been made for Louis XIII in Paris in 1642 by Henri Perlan from a cast of the antique original reworked by François Anguier.

Right: Fig.48
Henri Perlan (1597–1656)
Maidens adorning a Candelabrum
Bronze relief after an antique original
Height 72 cm. length 154 cm.
Musée du Louvre, Paris

the Quirinal in Rome (which, by coincidence, later became the Palazzo Pallavicini-Rospigliosi). Borghese certainly owned the relief by 1617 when it was installed in the Villa Borghese, together with another relief showing *Maidens adorning a Candelabrum* (also now in the Louvre) which, though smaller, was taken to be a pendant.[15]

We can distinguish two aspects to Poussin's relationship with antique sculpture, one archaeological, the other aesthetic. Although *A Dance to the Music of Time* is an allegory and not a subject from ancient history, it may nevertheless be intended to represent dance in the antique manner, the classical measured dance – or '*ballet mesuré*' – described in Mersenne's *Harmonie Universelle* (see p.30). We can see Poussin in one respect as attempting a reconstruction of the measured dance of the ancients using as his source the *Borghese Dancers,* which would probably have been the prime archaeological evidence available to him. On the other hand, there is clearly also a strong aesthetic response to the classical prototype. The sensuous, clinging draperies are retained in the drawing, while the weightier forms of the finished painting better capture the solemn grace of the carved figures.

The Wallace Collection relief

The Wallace Collection preserves a bronze relief of the *Borghese Dancers* (Fig.47), which seems to have been acquired by Sir Richard Wallace in the 1870s. This bronze relief was set into the wall of the entrance hall of Hertford House but, when a painting was hung in front of it, was soon forgotten. It was rediscovered by the first Keeper of the Wallace Collection, Sir Claude Phillips, who recognised the quality of the casting and published the relief as a work of the Italian Renaissance, with a tentative attribution to Riccio.[16]

This occasioned a debate in early issues of *The Burlington Magazine*. Bode suggested that the relief was a late-eighteenth century French casting, possibly by Gouthière or Thomire.[17] Eisler then pointed to the fact that the *Borghese Dancers* was among the antique reliefs from which casts were made for Louis XIII at the time of Poussin's trip to Paris, some of which were subsequently cast in bronze.[18] However, the discovery that a plaster cast of the relief was used in the decoration of Gouthière's house in Paris seemed to support Bode's idea.[19] At the same time it had been discovered that a bronze relief of the *Borghese Dancers* had been owned by the French sculptor Nicolas-François Lhuillier (active 1768, d.1793) and it was thus proposed that Lhuillier, rather than Gouthière, was the sculptor responsible.[20]

Nevertheless, the *Wallace Collection Catalogue of Sculpture* of 1931 maintained that the cast was one of those made for Louis XIII.[21] This view, thanks to recent discoveries, can now be argued with greater conviction. The interest of the Wallace Collection bronze is not simply in the fact that it reproduces, if freely, the antique original which Poussin knew. It seems that Poussin may have been indirectly, if not directly, involved in its production.

The decision to call Poussin back to Paris from Rome was made in 1638 by the newly-appointed Superintendent of the Royal Buildings, François Sublet de Noyers. At the same time Sublet de Noyers embarked on a programme of expansion for the royal collection of antique sculpture, which was to be achieved by acquiring plaster casts from Rome. This task was entrusted to the brothers Paul Fréart de Chantelou and Roland Fréart de Chambray who were sent to Rome in 1640 firstly to bring back Poussin and Duquesnoy, secondly to acquire casts.[22]

The Fréart brothers fulfilled this commission with diligence. Although Duquesnoy remained in Rome, they nevertheless arrived back in Paris with Poussin and were followed by thirty crates of casts. These included casts of the *Borghese Dancers* and its pendant of *Maidens adorning a Candelabrum*. Permission to make these had been obtained for the Fréart brothers through the diplomacy of Elpidio Benedetti.[23] All the casts, it seems, were made under the supervision of the French painter Charles Errard, who was then in Rome, and despatched to Paris by Adam Phillipon, a French joiner and engraver then in the service of the Pope. A number of casts were intended to be set into the vault of the *grande galerie* of the Louvre, the decoration of which was Poussin's chief concern during his years in Paris. Others were destined for the decoration of other royal palaces.

The casting of eight of these reliefs in bronze, including the Borghese reliefs, followed in 1642. A contract for the work was passed on 10 October,[24] shortly after

Poussin had set off for Rome, ostensibly with the purpose of bringing back his wife, but probably with no intention of returning. The founder responsible was Henri Perlan (1597–1656) who had already been working under Poussin's guidance on the decoration of the *grande galerie*.[25] The plaster cast itself was probably not a very good one. Charles Perrault later recalled that it arrived a rather formless thing, like a sketch, but that it had been consigned to the sculptor François Anguier (1604–69) to whom 'that marvellous elegance of the relief which we so admire' was due.[26] Anguier's work on the plaster presumably preceded the casting in bronze.

The Wallace Collection relief, together with a second bronze in the Louvre taken from the pendant relief of *Maidens adorning a Candelabrum* (Fig.48), are almost certainly those made by Perlan.[27] Metal analysis has shown that the bronze used for the two reliefs is of a very similar and rather unusual composition,[28] and comparison of the backs reveals detailed similarities in the method of casting. Moreover, it seems highly probable that the Louvre relief comes from the French royal collection and that it had remained in the royal collection since the seventeenth century. The Wallace Collection relief seems to have become separated when it was sent to Versailles in 1694 and it must later have been sold.[29]

Perlan's bronze reliefs were destined, as his contract states, for the decoration of the royal palaces. The specific use for which they were intended is not recorded, but it seems at least possible that they were to form part of Poussin's decoration of the *grande galerie* of the Louvre. Admittedly, it would be rather extraordinary to find such grandiose objects set into the vault of the gallery, but they could well have been set into the walls, perhaps over the doors.

There is thus the attractive possibility that the Wallace Collection *Borghese Dancers* is in fact one of the only surviving fragments of the largest project which Poussin ever undertook. Whatever the case, it will be clear in comparing the sensuous, rhythmic maidens of the bronze with their rather clumsy antique ancestors that François Anguier's contribution was a creative one. Placed next to one another the bronze relief of the *Borghese Dancers* and *A Dance to the Music of Time* represent two contemporary and complementary interpretations of the same antique prototype.

Aftermath

After Giulio Rospigliosi's death in 1669 his collection passed to his nephew Giovanni Battista Rospigliosi (1646–1722) and was installed in the Palazzo Pallavicini-Rospigliosi on the Quirinal. It then passed by descent to Domenico Clemente Rospigliosi (d.1752) and to his son, Camillo Rospigliosi (d.1769), who seems to have taken *A Dance to the Music of Time* to his palace near S. Maria Maggiore.[1] After Camillo's death the picture was returned to the Palazzo Pallavicini-Rospigliosi. It then passed to Camillo's brother, Giovanni Battista II Rospigliosi (d.1784), and thence to Giuseppe Rospigliosi (d.1832).

In 1803 Irvine, agent for the astute Scottish dealer William Buchanan, recorded that 8,000 crowns had been offered for *A Dance to the Music of Time* on behalf of the King of Naples. The offer had apparently been declined. Buchanan might have considered making an offer himself, but Irvine advised that *A Dance to the Music of Time*, together with the lost *Rest on the Flight into Egypt* (Fig.14), were 'rather dry' and 'such as I suspect would not do in England' (see p.65). In 1806 both pictures were purchased from Giuseppe Rospigliosi by Napoleon's uncle, Cardinal Fesch.[2] It was at the Fesch sale of 1845 that *A Dance to the Music of Time* was acquired by the 4th Marquess of Hertford, passing in 1870 to Sir Richard Wallace and forming part of Lady Wallace's bequest in 1897 to the British Nation. The place of the picture within the Hertford-Wallace Collection will be discussed in the following chapter.

Until Lady Wallace's bequest, *A Dance to the Music of Time* had always been in private collections: those of the Rospigliosi, Fesch, Hertford and Wallace. While all these

Opposite: *A Dance to the Music of Time*
Detail of Time and *putto* with an hour-glass

Below left: Fig.49
After Nicolas Poussin
A Dance to the Music of Time, 1667/9
Engraving by Etienne Baudet (1638–1711)
and Jean Dughet (1614–76)
Bibliothèque Nationale, Paris

Below right: Fig.50
After Nicolas Poussin
A Dance to the Music of Time
Engraving by Michael Burghers
(1653?–1727), published in the *Oxford Almanack*, 1694.
British Library, London

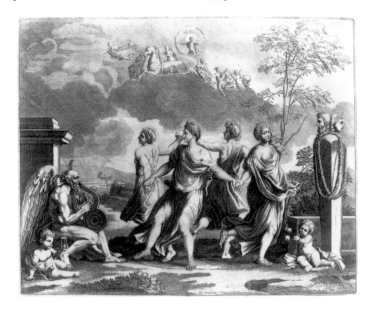

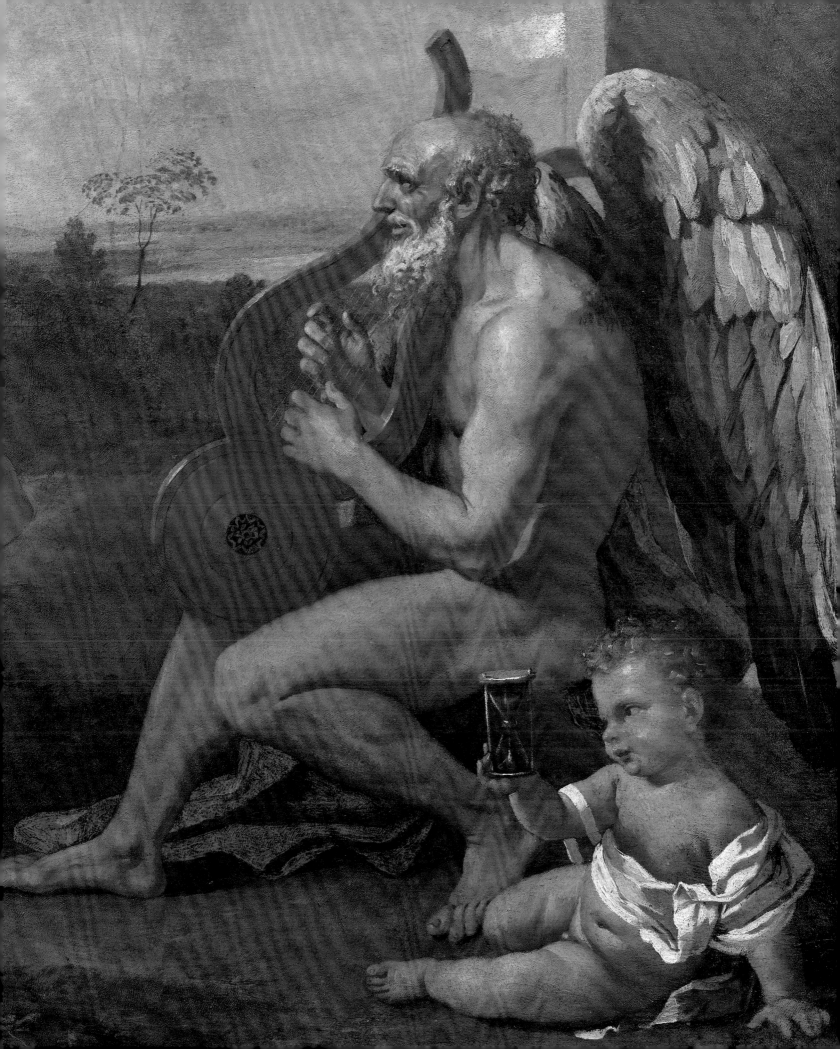

collections could be visited, the picture can never have been widely known. In 1864, even the Director of the National Gallery, Sir Charles Eastlake, seems to have been unaware that it was in Hertford's collection.[3]

Nevertheless, the picture was engraved, so far as we know, six times. In the late-seventeenth century, it would have been known through an engraving published by Poussin's brother-in-law, Jean Dughet.[4] This print was produced at the same time as that of *Time saving Truth* also from the Rospigliosi collection (Figs. 3, 49).[5] Both bear a dedication to Rospigliosi as Pope and thus were produced between 1667 and 1669. According to Florent Le Comte the engravings were in fact executed by the young French engraver Etienne Baudet, presumably to Dughet's commission.[6]

A Dance to the Music of Time was also known in England before the end of the seventeenth century in a copy after the Baudet-Dughet print by Michael Burghers which appeared in the *Oxford Almanack* in 1694 (Fig. 50). The press of Oxford University, under the direction of Dr John Fell, had been producing the *Almanack* since 1674, featuring in each issue a learned allegorical composition, often inventively stitched together from a variety of engraved sources.[7] Figures from Poussin's works were sometimes inserted into compositions along with figures or groups drawn from other artists, but *A Dance to the Music of Time* was already well suited to the task and required no adaptation.

Two further engravings appeared during the eighteenth century, one by the Dutch draughtsman and engraver Bernard Picart,[8] the other by Raphael Morghen[9] (Figs. 51, 52). Morghen's engraving reproduced the picture for the first time in its correct sense. In addition we know of two engravings made in the nineteenth century for books. An engraving by Massard appeared in the *Vie de Nicolas Poussin* by Gault de Saint-Germain published in 1806 (Fig. 53), and a simple outline print by E. Lingée was made for the *Œuvres Complètes de Nicolas Poussin*, published by Firmin Didot, Paris, in 1845 (Fig. 54).

But, if the picture was quite extensively reproduced, this was not enough to carry it to true celebrity. It never acquired a reputation to compare with that of the *Arcadian*

Fig. 51
After Nicolas Poussin
A Dance to the Music of Time, 1700/30
Engraving by Bernard Picart (1673–1733)
Courtauld Institute of Art, London

Fig. 52
After Nicolas Poussin
A Dance to the Music of Time, 1778/90
Engraving by Raphael Morghen (1758–1833)
British Museum, London

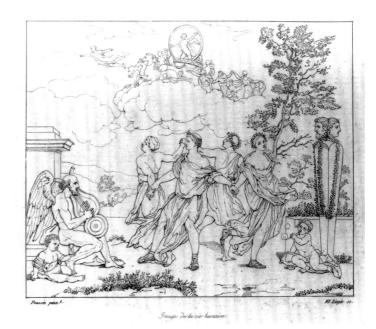

IMAGE DE LA VIE HUMAINE.

Above left: Fig.53
After Nicolas Poussin
A Dance to the Music of Time
Engraving by Massard for P.M. Gault de
Saint-Germain, *Vie de Nicolas Poussin,* 1806.

Above right: Fig.54
After Nicolas Poussin
A Dance to the Music of Time
Engraving by E. Lingée for *Œuvres Complètes
de Nicolas Poussin,* Firmin Didot, Paris, 1845.
Courtauld Institute of Art, London

Appollon fait danser les quatre Saisons

Fig.55
After an unknown painter
Dance of the Seasons, 1779
Engraving by Jean-Jacques Avril, *père*
(1744-1831)
Bibliothèque Nationale, Paris
The picture, now lost, was engraved in 1779
as a work by Poussin, but seems rather to be
an early-eighteenth century work showing
the influence of *A Dance to the Music of Time.*

Shepherds in the Louvre, for example (Fig.4).[10] And it is difficult to point to any specific instance of its influence on later artists.

An interesting adaptation occurs in a lost picture engraved in 1779 as a work by Poussin (Fig.55).[11] The attribution to Poussin is clearly mistaken and we are probably dealing with a work of the early-eighteenth century inspired, assuming the engraving is reversed, by a reversed engraving of *A Dance to the Music of Time.*[12] The figure of Time has been replaced by Apollo and Poussin's stately *ronde* has become a rather wild affair enacted by gods and goddesses symbolising the Seasons.

The composition of this anonymous picture seems close enough to Poussin to suggest a direct influence, but the meaning and character of the original are lost. The same might be said of a work by the Poussin follower Nicolas Loir, who may well have been influenced by the Baudet-Dughet engraving of *A Dance to the Music of Time* for a scene (possibly a *Dance of the Seasons)* painted on a ceiling in the Hôtel de Vigny in Paris in 1669 (Fig.56).[13] Similarly, Jacques Stella, who owned the drawing for *A Dance to the Music of Time,* seems to have used Poussin's composition for a pastoral dance, where the mood is purely bucolic (Fig.57).[14] Images of this kind could be traced through to the nineteenth century. For example, the *Nymphs and Satyrs* by George Frederick Watts in the Tate Gallery (Fig.58) may be influenced by *A Dance to the Music of Time* which Watts could have seen at the Fesch sale in 1845. But, if so, the response to Poussin is tangential.

We could multiply examples of the round dance in art and among them find those which share something of Poussin's gravity. But few derive evidently from *A Dance to the Music of Time.* It would be difficult to argue that the picture had any profound or sustained influence. This must be accounted for partly by the fact that the painting itself remained relatively inaccessible. But response to the picture also depends to some degree on an understanding of the allegory, and this caused persistent problems. Very few of those who saw the picture can have had any very clear notion of its meaning.

Even the descriptions of Bellori and Félibien had revealed a discrepancy, already

noted, in the identification of the figure of Pleasure, whom Bellori called Luxury. And Bellori also remarked on a resemblance – which is undeniable – to the subject of the Four Seasons. In this he was followed by Félibien, who added a further analogy of his own to the Four Ages of Man.

In the first decades of the eighteenth century we find an almost impeccable explanation of the subject in the legend which accompanies Picart's engraving (Fig.51). The text (see pp.64–5) derives from Félibien, but omits his misleading reference to the Seasons and the Four Ages of Man.

The guidebook to Rome produced by Francesco de' Ficoroni in 1744 was the first to add a touch of invention, in effect (though probably not consciously) reconciling the slightly discrepant descriptions of Bellori and Félibien. Thus Ficoroni describes the fourth figure neither as Pleasure, nor as Luxury, but as a combination of the two: 'luxurious Delight' (delizia lussuosa).

From the middle years of the eighteenth century, few authors attempted to identify the figures specifically. While it was still recorded that the picture represented an allegory of human life, the figures themselves were most often described as the Seasons. This may owe much to the influential collection of artists' lives published by A.J. Dézallier d'Argenville in 1745 (with a revised edition in 1762, see p.65). Dézallier's description was based on Félibien's, but it neglected to identify the dancing figures, while at the same time retaining the reference to the Seasons and the Ages of Man.

It was not long before the figures came to be identified positively as the Seasons. In 1769 Joseph Jérôme Le Français de Lalande described the picture in these terms and, not unreasonably given his assumption, criticised the characterisation of the figures (see p.65). If the Seasons were the subject then Poverty's wreath of dried leaves would clearly identify him as Autumn, and Pleasure's crown of roses would make her Spring. Thus Wealth becomes Summer, and the figure of Labour (which in fact derives, as we have seen, from Ripa's Summer Labour) becomes Winter.[15] Lalande noted two points: first Spring (Pleasure) was too old and should have been shown as a young girl of fifteen, second Winter (Labour) should have been shown fully clothed. He might have added that the seasons were out of sequence.[16]

The late-eighteenth century German critic, Friedrich Wilhelm Basilius von Ramdohr (c.1757–1822), seems to have interpreted the subject in the same way, but he was more forgiving about the characterisation (see p.65). He found the figures, at least as a group, quite comprehensible as the Seasons. These comments are to be understood in the context of a distrust of allegory, particularly when it was in any sense abstruse, which became prevalent in the second half of the eighteenth century. Later *A Dance to the Music of Time* was again defended in the same lingering debate by Antoine Chrysostôme Quatremère de Quincy (1755–1849), the stern advocate of neo-classicism in France. Quatremère argued that the inclusion of Aurora in a dawn landscape was unnecessary; the light and atmosphere of the landscape should alone be capable of expressing the time of day. But Poussin's use of Aurora was permissible because her purpose (along with Apollo) was to express not sunrise, but the brevity of human life, the notion that 'life is but a day'.

Both Le Français de Lalande and Ramdohr wrote enthusiastically about the picture's

Fig.56
Nicolas Loir (1624–79)
Dance of the Seasons?, 1669
Ceiling painting in the Hôtel de Vigny, Paris

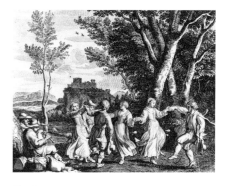

Fig.57
After Jacques Stella (1596–1657)
Pastoral Dance
Engraving by Claudine Bouzonnet Stella (1636–97)

Fig.58
George Frederick Watts (1817–1904)
Nymphs and Satyrs
Canvas 29.8 × 34.9 cm.
Tate Gallery, London

qualities, yet both also expressed reservations. The picture was one which could hardly fail to arouse admiration in the age of neo-classicism, but it was one which at the same time accorded only imperfectly with a late-eighteenth century aesthetic. Thus while there is admiration for the correctness and purity of the drawing and for the fluency and rhythm of the figures, Poussin's colouring was roundly criticised, and for Ramdohr the expressions on the faces of Time and Pleasure left much to be desired.

The first half of the nineteenth century saw renewed attempts to explain the allegory of human life. In 1806 Gault de Saint-Germain lists the figures more or less correctly as Wealth, Pleasure, Labour and Destitution *(la Misère)*, but the order in which he cites them suggests that he confused Poverty and Labour. Gault de Saint-Germain still regarded the figures as emblematic of the Seasons and arrived at an interpretation which is in effect that suggested more succinctly in the title proposed for the painting by Laoureins in 1814: *Les saisons de la vie* (the seasons of life). The central theme is still the vanity of life and the fact of its inevitable fading.

The interpretation proposed by Smith in his Poussin catalogue of 1837 is more novel, but considerably wider of the mark. For Smith the dance represented the pursuit of pleasure, the aim of man whatever his condition. The distinctions between the figures merely indicate that all classes of men contribute to the attainment of pleasure.

It is unlikely that either of these interpretations was known to Cardinal Fesch, in whose collection the picture bore the title *The Dance of the Hours*. It was described as such by Thomas Moore who visited the collection in 1819 and it appeared under this title in the summary Fesch catalogue of 1841. However, when the picture was put up for sale in 1845, the author of the sale catalogue attempted once more to unravel the supposed two-fold allegory of the Seasons and Human Life. Poverty's wreath of dry leaves was taken for a wreath of laurel and he was thus identified as Glory, while at the same time representing Autumn. Labour was wrongly interpreted as Poverty and also taken to stand for Winter. Wealth became Opulence and doubled as Summer. And Pleasure continued to fulfil her eighteenth-century role as Spring. In consequence the picture was taken to express a cycle of the Seasons in which Summer followed Winter and Spring Summer. And the allegory of human life was, by implication, one in which Poverty leads to Opulence, Opulence to Pleasure, Pleasure to Glory, Glory in turn being rewarded by Poverty.

Thus when Lord Hertford acquired the picture at the Fesch sale, confusion as to its precise subject had reached an advanced stage. In his collection the picture was known as *The Dance of the Seasons*. It remained a *Dance of the Seasons* for Wallace and, when the Wallace Collection opened to the public in 1900, continued to bear the same title. The present poetic title in fact arose by chance. It was expanded in the 1909 edition of the Wallace Collection catalogue, not without a certain pedantry, to read *The Dance of the Seasons to the Music of Time*. This was the title which had been used when Hertford lent the picture to the Art Treasures exhibition in Manchester in 1857. But the compiler of the 1913 edition finding, by reference to Smith's catalogue, that the subject had been wrongly identified, suppressed the reference to the Seasons and replaced the definite article with the indefinite.

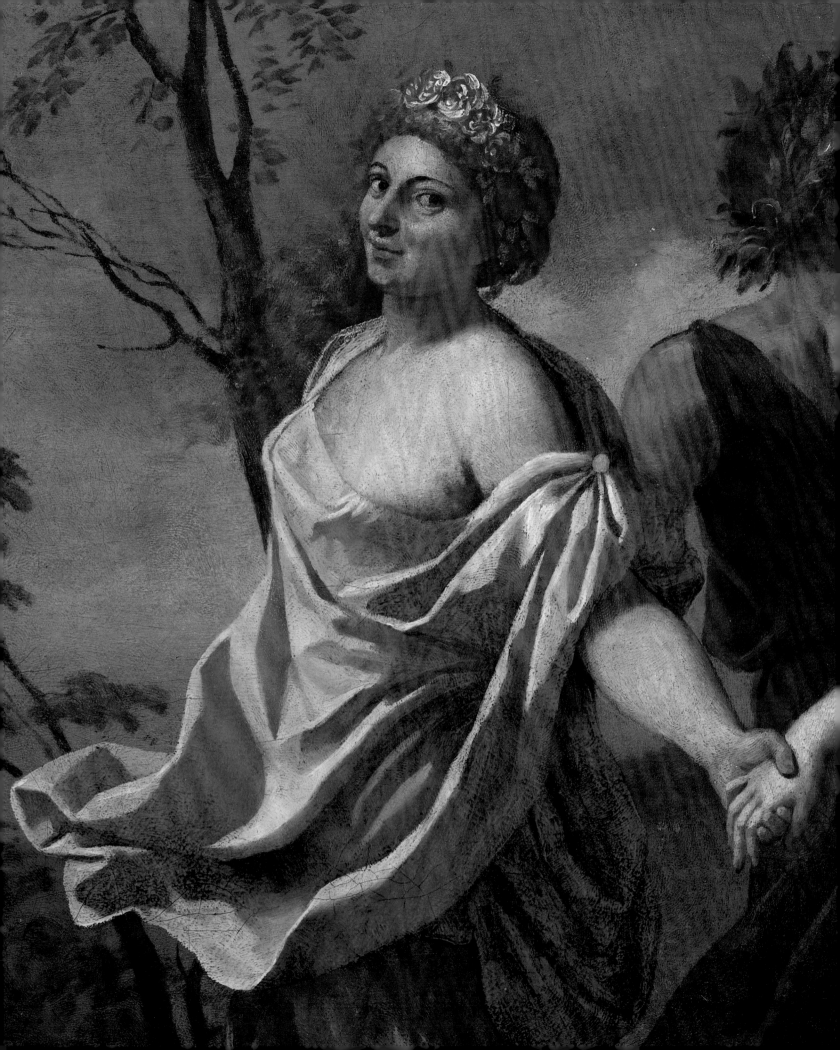

Poussin, Lord Hertford and British Collectors

by Robert Wenley

Poussin and Lord Hertford

The 4th Marquess of Hertford (1800–70) purchased *A Dance to the Music of Time* for 5,970 *scudi* (about £1,200) at the Fesch sale, held in Rome from 17 March to 15 May 1845 (lot 397). He then sent the picture to London, either after the sale or more probably in 1848, when he travelled to England to escape the political disturbances in Paris. Many of his acquisitions made between 1842 and 1847 in Paris or Rome seem to have come to London at this time. The German scholar Gustav Waagen listed the Poussin and other Fesch purchases in London when he visited in 1850, although he may not have seen it since 'the bulk of the collection' was in storage.[1] In 1857 Lord Hertford lent the painting, with forty-three others from London, to the great Manchester Art Treasures exhibition. The following year it was probably redisplayed, as most of his London collection certainly was, in Manchester (now Hertford) House,[2] where it remains today.

Lord Hertford divided his life between London and Paris, and although he rarely visited England after 1850, and never after 1855, he continued to maintain his properties there. The available evidence seems to reveal a clear distinction in the character of his collections in the two countries.[3] In Paris, Lord Hertford, like several other collectors of comparable wealth, acquired works of art of the *ancien régime*, together with Dutch and Flemish paintings of the kind admired by aristocratic collectors of the eighteenth century, and contemporary French pictures. For London, by contrast, he assembled a gallery of those old masters which had formed the canon of 'good taste' in Britain since the eighteenth century. The hierarchy was headed by the Bolognese, Florentine and Roman schools (of which Poussin was an honorary member), and included the great Venetian and Flemish masters.

Together with *A Dance to the Music of Time*, Lord Hertford's London collection included works by Claude and Dughet (also honorary Romans), Albani, Annibale Carracci, Cima, 'Dolci' (now Attributed to Marinari, P562), Domenichino, 'Giorgione' (now Ascribed to Titian, P19), Luini, Salvator Rosa, Del Sarto and Sassoferrato, as well as paintings by Rubens, Murillo, Velázquez, Zurbarán, Reynolds and a wide range of Dutch masters.[4] There were few eighteenth-century, and virtually no nineteenth-century, French pictures. The contrast with his Paris collection is so marked as to suggest that the distinction was deliberate rather than simply a consequence of local saleroom availability. Indeed, of the acquisitions made in Paris and Rome in 1842–7, it was the old masters which came to England, probably in 1848, while most of the French eighteenth- and nineteenth-century paintings were left in France.[5]

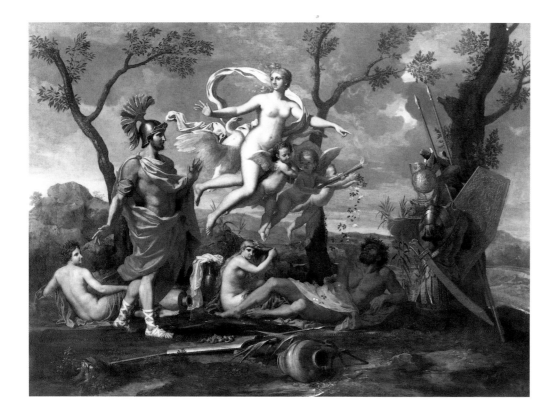

Fig.60
Nicolas Poussin (1594–1665)
Venus bringing arms to Aeneas
Canvas 105 × 142 cm.
Musée des Beaux-Arts, Rouen

Even when Lord Hertford began collecting, at about the time he succeeded to his title and wealth in 1842, the conventional British taste which his London collection represented was being challenged by new fashions, in particular the vogue for Italian and Netherlandish 'primitives'.[6] By the later 1850s, this fashion was widespread among avant-garde British collectors, but by then Lord Hertford had moved permanently to Paris, where the taste for the early Renaissance was less prevalent. He had in any case expressed to his London agent, Samuel Mawson (1793–1862), his antipathy towards 'Primitive Masters', 'that I have not yet adopted & that I don't think I ever will'.[7]

Thus, in the years before Lord Hertford moved finally to Paris, he purchased a group of paintings very much in the taste of his father's generation. The 4th Marquess had lived in England in the later 1810s and 1820s, and doubtless visited the major London auctions and successive British Institution exhibitions (at which masterpieces from private collections were exhibited).[8] These experiences may well have shaped his understanding of 'correct taste' in old masters, and formed the basis of his own preferences. But by the 1840s these were beginning to become old-fashioned.

Lord Hertford's correspondence with Mawson indicates that he sought to assemble a strong representation of such traditional taste, and his agent often urged particular acquisitions which he thought suitable. At the Northwick sale of 1859, for example, Mawson drew Lord Hertford's attention to 'Lot 991 – N. Poussin a very first rate/clear/specimen [which] ought to be secured.'[9] This was the *Venus bringing arms to Aeneas* of 1639 (Fig.60). We do not know why it was rejected, but Lord Hertford perhaps felt both then, and earlier in 1850 when he had taken Mawson's advice and spurned *The Birth of Bacchus* of 1657 (Fogg Art Museum, Cambridge, Massachusetts), that one first-rate Poussin was sufficient to represent the artist.

In the same spirit, he tended to buy only at the most prestigious auctions, where he would invariably cream off the masterpieces. This might be viewed simply as wealth combining with fine judgment; but there may have been an element of personal triumph in acquiring the greatest *chefs d'œuvre* from so many other famous collections — particularly one formed by a figure so well-connected as Cardinal Fesch.

Joseph Fesch (1763–1839), maternal uncle of the Emperor Napoleon I, had accumulated possibly the greatest, certainly the largest, private collection of paintings in the world (16,000 were inventoried after his death).[10] His rise in fortune followed that of his nephew, who provided him with a succession of advantageous posts in Italy and France, most usefully that of French Ambassador to the Vatican (from 1803). As he amassed almost limitless wealth, so he was able to feed his seemingly omnivorous appetite for paintings of all schools and periods. His apparent lack of discrimination was criticised by contemporaries, but often he had been obliged to buy job lots in order to secure a specific masterpiece. Undoubtedly his collection contained outstanding Flemish, Dutch and French paintings in particular. Despite his exile after Napoleon's fall, Fesch retained some of his wealth and continued to acquire pictures, the majority of which were sold between 1841 and 1845. The Cardinal's collection had been one of the most celebrated in Europe, and *A Dance to the Music of Time* was among the finest paintings within it. There were perhaps four further original Poussins (including Rospigliosi's *Rest on the Flight into Egypt*), as well as about a dozen copies.[11]

Lord Hertford's motives for acquiring *A Dance to the Music of Time* at the Fesch sale are not recorded and doubtless included admiration for the picture. However, given the context of his other acquisitions for London, the purchase may have been motivated in part by a belief that Poussin was currently fashionable in Britain. If so, the evidence suggests that Lord Hertford was decidedly out of date. His painting was probably the first major Poussin to enter England for twenty years and perhaps the last until the 1920s. Of course, the many Poussins already in this country continued to circulate at auction, but sale prices indicate that even by the 1830s British interest in the artist was in decline.

Poussin and British Collectors

Even though few of Poussin's paintings were to be found outside Italy or France until after his death, British taste for his work may date back to his own lifetime. In 1639, the Marquess of Hamilton apparently acquired from the painter-dealer Niccolò Renieri a '*quadro d'amorini di Monsù Poussino*', perhaps the *Two Children* at Wilton House.[12] This is in fact a partial copy, albeit a fine and early one, of the *Bacchanal before a Herm* of c.1633 (Fig.30). In the late-seventeenth century, several further paintings attributed to Poussin feature in London sales, but those that have been traced are all, with one exception, also copies. These include a copy of the *Death of Germanicus* (original in the Minneapolis Institute of Arts) which Sir Thomas Isham commissioned from Giovanni Remigio in 1677.[13] This act is evidence of the growing British interest in Poussin, a trend further indicated by the increasing availability of prints after his works and references to him in journals and letters in the late-seventeenth century.

The one genuine Poussin known to have entered Britain before the eighteenth century is the *Venus and Mercury*, imported by the painter-dealer Lankrinck, and sold by him in London in 1693.[14] After various journeys around Europe, and having been split in two, the painting is now represented in this country by the right-hand section, which entered the Dulwich Picture Gallery as part of the Bourgeois bequest in 1811.

This was the first of nearly one hundred surviving original paintings by Poussin known to have been in Britain at some stage in their history, from a total *œuvre* numbering about 230. Few other major artists were so well represented in Britain in the eighteenth century.[15] Nearly fifty works, including recent discoveries and attributions, remain in this country, a number only just surpassed in France itself. Merely a handful, of which *A Dance to the Music of Time* is one, can still be seen within the context of the collections for which they were acquired in the eighteenth and nineteenth centuries.

Over sixty works were imported in the eighteenth century, and at least a dozen more during the Napoleonic period, the upheavals of which in Europe, together with the disturbances in France during the 1790s, had prised vast quantities of old masters from numerous prestigious collections. Britain, being the richest and most powerful nation of the time, was well placed to secure the lion's share.

The period 1790–c.1825 saw the arrival of some of the greatest Poussins, particularly those from the celebrated Orléans collection, and others mostly now in the National Gallery, London; but about fifty were already in the country. The evidence of sale catalogues and other documents, although not complete, points to a rise of interest in the 1730s, and again from the 1770s, with the activity around the turn of the century merely the climax of long-standing demand for Poussin's works.

While the Chantelou *Seven Sacraments* from the Orléans collection (National Gallery of Scotland, Edinburgh, Sutherland loan) arrived in 1798, and Dulwich acquired its fine group in 1811, earlier decades had seen the arrival of many other Poussins of the first order. Sir James Thornhill had purchased the poetic *Tancred and Erminia* in 1717 (Barber Institute of Fine Arts, Birmingham).[16] In the 1730s and 1740s, Sir Robert Walpole acquired three major works, all now in Russia, and only a papal export ban prevented his acquiring the Dal Pozzo *Sacraments*, eventually bought by the Duke of Rutland in 1785 (five of the seven are still at Belvoir Castle, Rutland).[17] Other important acquisitions include those made by Earl Waldegrave when Ambassador in Paris in the 1730s, by the dealer Samuel Paris in 1741/2, by the Duke of Devonshire in the early 1760s (or before), Lord Clive in the 1770s, and the Marquess of Lansdowne in the 1780s.[18] In addition there were countless copies and wilful or ignorant misattributions. These seem to have been particularly prevalent in the 1770s, perhaps some indication that demand was then outstripping supply.

The development of taste for Poussin in Britain was clearly a product of the Grand Tour, the ultimate goal of which was invariably Rome, Poussin's adopted city. Poussin's brand of classical revival was certain to appeal to the eighteenth-century British *milordi* weaned on the splendours of Rome and antique culture. His style owed much to that classical heritage, while his edifying and ennobling subject matter accorded with eighteenth-century principles of good taste and morality. The classical landscapes of Claude and Dughet, and the restrained architectural models of Palladio were praised for

the same reasons. Today an expression of this taste is perhaps best seen in the ensemble of house and landscape at Stourhead (Wiltshire) – which still retains one of the two Poussins acquired by Henry Hoare (1705–85) in the mid-eighteenth century, along with a curious collage copy of *A Dance to the Music of Time*.[19]

Poussin's qualities of rationalism and restraint were less admired in Britain by the mid-nineteenth century. This can be seen, for instance, in the steadily declining interest shown by critic and copyist alike in the celebrated Poussins at Dulwich, once among the principal attractions of that gallery.[20] This development is also reflected in the saleroom fortunes of his paintings. When the new record price for a Poussin was set in 1807 (at £1,575), it was not surpassed until 1924; each of the two previous records had lasted only six years.[21] Perhaps more tellingly, the *Flight into Egypt* bought by the Reverend Finch in 1825 (now Worcester Art Museum, Massachusetts) was probably the last Poussin to be imported (with the exception of two works owned by the dealers Smith and Buchanan) until the arrival of *A Dance to the Music of Time* in about 1848. And only one other painting, the recently rediscovered *Landscape: A Calm* at Sudeley Castle (Gloucestershire),[22] seems to have entered Britain from that date till the 1880s, by which time the reverse process – the widespread export of Poussins – had begun.

Conclusion

British collectors had always preferred Poussin's more sensuous and lyrical manner (and thus generally his earlier mythological paintings), as statements made by critics such as Irvine suggest.[23] In France, by contrast, Poussin's intellectual and philosophical side was more revered.[24] *A Dance to the Music of Time*, which so successfully combines these contrasting aspects of Poussin's art, therefore seems a particularly appropriate acquisition for the Francophile Lord Hertford.

Lord Hertford's decision to buy *A Dance to the Music of Time* might nevertheless appear puzzling given the painting's serious, moralising subject-matter, which rather sets it apart in the Wallace Collection.[25] In fact, it seems unlikely that the 4th Marquess understood the true theme of the painting (see p.53). A warning of the perils of pleasure indulged would not have appealed to one of history's greatest epicureans. But had Lord Hertford perceived the painting's intended message, he would surely have delighted in cheating it of its moral that wealth enjoyed to excess will ultimately lead to poverty.

Notes

References by author and date are to the bibliography of *A Dance to the Music of Time* on pp.74–6. References to works which do not mention the Wallace Collection painting are given in full.

The Patron: Giulio Rospigliosi

1 The Guercino (*c*.1618) is in the Galleria Nazionale, Rome, the Poussin (*c*.1628/9) at Chatsworth, Derbyshire.

2 *Time saving Truth from Calumny* is the subject of a woodcut illustration to the *Cinque Messe* by Adriaen Willaert, 1536 (F. Saxl, 'Veritas Filia Temporis', *Philosophy and History, essays presented to Ernst Cassirer*, Oxford, 1936, pp.197–222, fig.2).

3 For Rospigliosi's biography, see G. Beani, *Clemente IX, Giulio Rospigliosi Pistoiese*, Prato, 1893; L.F.A. von Pastor (tr. E. Graf), *The History of the Popes*, XXXI, London, 1957, pp.314–430, L. Osbat and R. Meloncelli, in *Dizionario Biografico Italiano*, 26, Rome, 1982, pp.282–93 (hereafter DBI); and M. Murata, *Operas for the Papal Court, 1631–1668*, Michigan, 1981, pp.1–11.

4 Fumagalli 1994–5, p.51.

5 DBI, p.283; Pastor, *op. cit.*, XXXI, p.320, gives 1632; Murata, *op. cit.*, p.4 records him in this position only from 1634.

6 DBI, *loc. cit.*; Pastor, *loc. cit.*, gives 24 December 1636.

7 DBI, *loc. cit.*; Pastor, *loc. cit.*, gives 1641.

8 Murata, *loc. cit.*, with the dates 4 January 1642 and 27 July 1643; DBI, *loc. cit.*, gives 1641 for the office of '*consultore canonista*'; Pastor, *loc. cit.*, gives 1643 for the same.

9 DBI, *loc. cit.*, gives 1642; Pastor, *loc. cit.*, gives 1643.

10 This at least is the implication of a letter to his family in which he refers to an unfavourable '*congiuntura de' tempi*' (29 August 1643, quoted in DBI, p.284).

11 Murata, *op. cit.*, p.7.

12 Murata, *op. cit.*, p.9.

13 For poetry and discourses published 1625–9, see G. Canevazzi, *Papa Clemente IX, Poeta*, Modena, 1900, pp.56–9, Murata, *op. cit.*, p.4, and DBI, p.290. His sonnets included one in honour of the celebrated singer Leonora Baroni, who was also admired by Milton (A. Ademollo, *I Teatri di Roma del Secolo Decimosettimo*, Rome, 1888, pp.25–6).

14 F. Bracciolini, *L'Elettione di Urbano Papa VIII ...*, Rome, 1628.

15 On this subject, see Murata, *op. cit.*; Canevazzi, *op. cit.*; and V. Kapp, 'Das Barberini-Theater und die Bedeutung der Römischen Kultur unter Urban VIII. Versuch einer literarhistorischen Einordnung des Schaffens von Giulio Rospigliosi', *Literaturwissenschaftliches Jahrbuch*, 26, 1985, pp.75–100.

16 See Ademollo, *op. cit.*, pp.10ff., and Murata, *op. cit.*, pp.19–23, 221ff. The 1632 performance was described in the journal of Jean-Jacques Bouchard (see Haskell 1980, pp.56–7). For the text, see A. della Corte (ed.), *Drammi per musica*, Turin, 1958, I, pp.195–266. A performance was given in Rome in 1981.

17 For the documentation on Cortona's involvement in 1632, see I. Lavin, *Seventeenth-century Barberini documents and Inventories of Art*, New York, 1975, pp.12ff., doc.99, and J.M. Merz, *Pietro da Cortona*, Tübingen, 1991, p.106.

18 The sets for the 1634 performance are attributed on Collignon's engravings to 'F.B.', i.e. Francesco Buonamici, not as is sometimes said Bernini (see P. Bjurström, *Den Romerska Barockens Scenografia*, 1977, pp.24–31).

19 The legation certainly saw Spanish plays (see Murata, *op. cit.*, p.196 n.9).

20 See S. Reiner, 'Collaboration in Chi soffre speri', *The Music Review*, XXII, 1961, pp.265–82.

21 Milton to Lucas Holstenius, Florence, 30 March 1639 (see Ademollo, *op. cit.*, pp.25–7).

22 See F. Hammond, 'Bernini and the "Fiera di Farfa"', in I. Lavin (ed.), *Gianlorenzo Bernini, New Aspects of His Art and Thought*, Pennsylvania State University and London, 1985, pp.115–78.

23 *La Vita Humana ovvero Il Trionfo della Pietà, dramma musicale rappresentato e dedicato alla Serenissima Regina de Svetia*. The performance was described by G. Priorato, *Historia della Sacra Real Maestà di Christina Alessandra, Regina di Svetia*, Venice, 1656, pp.234–6. See P. Bjurström, *Feast and Theatre in Queen Christina's Rome*, Stockholm, 1966, pp.23ff., and W. Witzenmann, 'Die römische Barockoper La Vita humana ovvero il Trionfo della Pietà', *Analecta Musicologica*, 15, 1975, pp.158–201.

24 In a letter of 28 November 1646 (L. Indrio, '"Colli di pitture", una collezione e una pala d'altare: materiali per una parentesi romana nella pittura del Seicento a Pistoia', in M.C. Mazzi (ed.), *Museo Civico di Pistoia. Catalogo delle collezioni*, Florence, 1982, pp.253–4).

25 Giulio to Camillo Rospigliosi, 5 June 1637 (quoted by J.B. Scott, *Images of Nepotism, The Painted Ceilings of the Palazzo Barberini*, Princeton, 1991, p.132 n.47): '*Volendo mandar vostra qualche cosa buona ho stimato meglio haver pazienza che per sollecitar troppo havere cosa ordinaria*'.

26 The 1713 inventory is published in Zeri 1959, pp.299–330.

27 By Elena Fumagalli.

28 A. Sutherland Harris, *Andrea Sacchi*, Oxford, 1977, pp.82–4.

29 Murata, *op. cit.*, pp.222, 301.

30 Galleria Nazionale, Rome (see H. Zerner, 'On the Portrait of Giulio Rospigliosi, and its attribution to Poussin', *The Burlington Magazine*, CIII, 1961, pp.66–7, and Thuillier 1994, p.269, R4).

31 Zeri 1959, p.300, no.42.

32 Zeri 1959, p.306, no.220.

33 Fumagalli 1994–5, p.51; and see Indrio, *op. cit.*, pp.254ff..

34 According to B. de Dominici, *Vite dei Pittori, Scultori ed Architetti Napoletani*, Naples, 1742–5, III, pp.320–2. Rospigliosi presumably also commissioned from Mattia the two versions of *Sophonisba* recorded in later Rospigliosi inventories; see F. Piccirillo, 'Note Biografiche e Documentarie', in E. Corace (ed.), *Mattia Preti*, Rome, 1989, p.61 n.22.

35 M. Röthlisberger, *Claude Lorrain: The Paintings*, London, 1961, I, p.127.

36 This story, related by Baldinucci, is associated with the National Gallery picture by Röthlisberger, *op. cit.*, I, p.128.

37 Röthlisberger, *op. cit.*, I, pp.127–31 (Liber Veritatis, no.15).

38 Röthlisberger, *op. cit.*, I, pp.162–4, 212–14 (Liber Veritatis, nos.34, 70). M. Röthlisberger, *Claude Lorrain: The Drawings*, London, 1968, I, pp.327–8, no. 879.

39 Described as Poussin in the 1713 inventory (Zeri 1959, p.324, no.620); regarded by Blunt as a copy of the foreground *putto* in the *Nurture of Jupiter* at Dulwich (Blunt 1966, no.161), but given to Poussin by: Thuillier 1974, no.23 (Blunt accepted the possibility in his review, *The Burlington Magazine*, CXVI, 1974, p.761); K. Oberhuber, *Poussin, The early years in Rome*, cat. exh. Kimball Art Museum, Fort Worth, 1988, no.9; Mérot 1992, no.172; and Rosenberg and Prat 1994–5, p.234. The 1713 inventory also includes a picture of *Two Putti embracing*, as after Poussin, now lost (Zeri 1959, p.322, no.572; Blunt 1966, L92).

40 Though, if the Prado picture is the one seen by Félibien in the house of the sculptor Carlo Mattei in 1647, it seems unlikely that Rospigliosi commissioned it (see Rosenberg and Prat 1994–5, no.45).

41 Zeri 1959, p.310, no.302.

42 National Gallery Archives, Eastlake Notebooks, 1864, I, fol.5r (I am most grateful to Sir Denis Mahon for this reference). The collection was that of '*M. Fourcade – Rue du Tapis Vert*'.

43 Zeri 1959, p.308, no.251; Blunt (1966, no.52) associated this reference with the *Holy Family in a Temple* in the Musée Condé, Chantilly. Rosenberg rejects the Chantilly picture as Poussin, but seems to retain the Rospigliosi provenance (P. Rosenberg and L.-A. Prat, *Nicolas Poussin. La collection du musée Condé à Chantilly*, cat. exh. Musée Condé, Chantilly, 1994–5, no.8).

44 Zeri 1959, p.306, no.210.

45 Zeri 1959, p.324, no.625.

46 Blunt 1966, L82. Thuillier (1994, no.233) thinks the Hermitage painting might be an unfinished work by Poussin of *c*.1657–60. It is accepted by Mérot (1992, no.191) and by Rosenberg (Rosenberg and Prat 1994–5, no.79), who proposes a date in the late 1630s.

47 Poussin returned to the subject in later drawings which Rosenberg dates 1649–50 (see Rosenberg and Prat 1994–5, nos.79–82); however, if a slightly later dating were permissible for these drawings, they could have been made on Rospigliosi's return in 1653.

48 Zeri 1959, p.320, no.522. This is probably the copy sold at Christie's, 23 March 1934 (lot 87), with a Rospigliosi provenance and now in a private collection, Paris (not London, as stated in Ingamells 1989, p.311).

49 Including copies after Poussin of a *Flight into Egypt* and a *Nativity* (Fumagalli 1994–5, p.51).

50 Zeri 1959, p.309, no.289.

51 DBI, p.288.

52 See P. Bjurström, *op. cit.* at note 23, pp.53–5.

Subject and Meaning

1 C. Ripa, *Iconologia overo Descrittione di diverse Imagini cauate dall'antichità, & di propria inuentione*, Rome, 1603. For Poussin's use of Ripa in *A Dance to the Music of Time*, see Panofsky 1936, p.241 n.2, and Blunt 1976.

2 Ripa, *op. cit.*, p.409.

3 E. Newby, *Love and War in the Apennines*, London, 1971 (ed. 1983), p.162: 'the two beds, one of which I was occupying, were made with the trunks of young trees and the mattresses were boughs with the leaves still on them, dead and browned by the heat of the fire'.

4 Ripa, *op. cit.*, pp.145–6.

5 *Ibid.*, p.434.

6 *Ibid.*, pp.398–9 and see Blunt 1976. Ripa had in fact placed this crown of roses on a handsome youth of sixteen dressed in green, holding a line of hooks and a bunch of flowers.

7 The peacock appears in later editions of Ripa as an attribute of Luxury and this may derive from a source, as yet unlocated, which Poussin knew.

8 J.–P. Valeriano, *Hiéroglyphiques*, Lyon, 1615, p.297.

9 See Panofsky 1936 (quoted on p.68 below).

10 I am most grateful to Elisabeth McGrath for drawing this print to my attention.

11 M.N.K. Mander, 'Milton and The Music of the Spheres', *Milton Quarterly*, 24, 1990, pp.63ff.

12 See E.M.W. Tillyard, *The Elizabethan World Picture*, London, 1963, pp.123ff.

13 Philostratus (tr. Blaise de Vigenère), *Les images ou tableaux de platte peinture …*, Paris, 1614. I am again grateful to Elizabeth McGrath.

14 Poussin perhaps also knew Pierre Brebiette's etching of the *Dance of the Seasons*, datable before 1625 (illustrated in Thuillier 1994, p.90). I am most grateful to Jacques Thuillier for suggesting this connection.

15 This is to take a somewhat different view from Panofsky's, but it seems difficult to take Poussin's dance as other than perpetual and inevitable.

16 A. Ademollo, *Teatri di Roma*, Rome, 1888, pp.86ff., as possibly by Rospigliosi, but not included in Margaret Murata's study of Rospigliosi's operas (*Operas for the Papal Court, 1631–1668*, Michigan, 1981).

17 Ademollo, *op. cit.*, pp.54–5.

18 M. Mersenne, *Harmonie Universelle contenant la théorie et la pratique de la musique*, Paris, 1636.

19 See also Marc Fumaroli's arguments concerning the *Inspiration of the Epic Poet* in the Louvre (*L'Inspiration du poète de Poussin*, cat. exh. Louvre, Paris, 1989, reprinted in M. Fumaroli, *L'Ecole du Silence*, Paris, 1994, pp.53–147).

Evolution of the Composition

1 A painting appeared in the Lethières sale, Paris, 24 November 1829 (lot 61) described as '*Première pensée de la composition d'après laquelle Morghen a fait sa belle gravure*'. Since Morghen engraved only two of

Poussin's pictures, there is a fifty percent chance that this refers to *A Dance to the Music of Time*. The picture was said to come from the Boccapaduli family who were heirs of Poussin's patron Cassiano dal Pozzo (see Blunt 1965, p.62).

2 I am grateful to Sir Denis Mahon who points out that the evidence of the '1634 inventory' listing this picture and referred to by R. Ferretti ('A preparatory drawing for one of the dal Pozzo paintings of scenes from the life of Moses', *The Burlington Magazine*, CXXVII, 1985, pp.617–21) seems not in fact to be conclusive for the dating as it includes other pictures which are certainly later than 1634.

3 No paint samples have been taken for analysis. On Poussin's ground preparations, see A.R. Duval, 'Les enduits de préparation des tableaux de Nicolas Poussin', *Techne*, 1, 1994, pp.35–41.

4 For the dating proposed by various scholars before 1989, see Ingamells 1989, p.310. A date of 1638–40 is accepted, or at least not challenged by Mérot 1990, p.288, Rosenberg and Prat 1994–5, p.278, and Thuillier 1994, p.256. Mahon would now favour a dating of 1634/5 having previous suggested 1637/8 (oral communication).

Visual Sources

1 I am most grateful to Jennifer Montagu for all the evidence below relating to the Duquesnoy models.

2 J.G. Mann, *Wallace Collection Catalogue of Sculpture*, London, 1931, pp.74–5, S198–9.

3 *Ibid.*, p.75, S200–1.

4 J. Bousquet, 'Chronologie du séjour romain de Poussin et de sa famille', in A. Chastel (ed.), *Actes du colloque International Nicolas Poussin*, Paris, 1960, II, p.4. On the relationship between Poussin and Duquesnoy, see also A. Nava Cellini 'Duquesnoy e Poussin: nuovi contributi', *Paragone*, 17, 1966, pp.30–59, and K. Oberhuber, *Poussin: The Early Years in Rome*, cat. exh. Kimbell Art Museum, Fort Worth, 1988, pp.116–18.

5 They are thus generally dated 1626, though Oberhuber gives 1628 (*loc. cit.*).

6 For the Duquesnoy model, see I. Faldi, 'Le virtuose operazioni di Francesco Duquesnoy scultore incomparabile', *Arte antica e moderna*, 5, 1959, pp.52–62.

7 E. Bourgeois and G. Lechevallier-Chevignard, *Le biscuit de Sèvres, I, recueil des modèles de la Manufacture de Sèvres au XVIII^e siècle*, n.d. [1913], plate 5.

8 Bellori 1672, p.271.

9 J. Martineau (ed.), *Andrea Mantegna*, cat. exh. Royal Academy, London, 1992, nos.138–9.

10 Gombrich 1950, p.190 n.2.

11 Reproduced in F. Hartt, *Giulio Romano*, New Haven, 1958, II, pl.278.

12 On the reputation of the relief, particularly in the eighteenth century, see F. Haskell and N. Penny, *Taste and the Antique*, New Haven and London, 1981, pp.195–6.

13 On the influence of the relief in the Renaissance, see P. Pray Bober and R. Rubinstein, *Renaissance Artists and Antique Sculpture, A Handbook of Sources*, Oxford, 1986, p.95 (citing also drawings of each figure in the Fossombrone sketchbook from Raphael's workshop and an incorrect reconstruction of the relief from Cassiano dal Pozzo's 'paper museum').

14 But cf. P.W. Lehmann, *Revue Archéologique*, 1968, pp.197–214.

15 The date is given in a document discovered by Katrina Kelveram. The reliefs passed to Camillo Borghese from whom they were purchased, along with other Borghese antiquities, by Napoleon Bonaparte on 20 September 1807. They were despatched to Paris between 1808 and 1811 and were on display in the Louvre by 1820 (C.O.F.J.B de Clarac, *Description des Antiquités du Musée Royal*, Paris, 1820, pp.12–13).

16 C. Phillips, 'A Bronze relief in the Wallace Collection', *The Burlington Magazine*, IV, 1904, pp.111–24.

17 W. Bode, *ibid.*, p.215; and C. Phillips, *ibid.*, pp.215–16 (maintaining his view).

18 R. Fisler, *ibid.*, V, 1904, p.591.

19 E. Michon, 'Note additionelle sur un bas-relief de bronze du Musée du Louvre', *Fondation Eugène Piot, Monuments et Mémoires*, XIII, 1906, pp.107–16.

20 E. Michon, 'Un bas-relief de bronze du Musée du Louvre', *ibid.*, XII, 1905, pp.159–76; and L. Deshairs, 'Recherches sur le sculpteur Lhuillier', *Bulletin de la Société de l'Histoire de l'Art français*, 1907, pp.66–71.

21 Mann, *op. cit.*, p.57.

22 See A. Le Pas de Sécheval, 'Les missions romaines de Paul Fréart de Chantelou', *XVII^e Siècle*, 172, 1991, p.259–74.

23 Benedetti's letter to Mazarin on this subject, of 7 July 1640, is reproduced by Le Pas de Sécheval, *op. cit.*, p.265.

24 N. Sainte-Fare Garnot, 'Le décor de la grande galerie du Louvre au temps de Poussin. Marchés pour les lambris et la dorure de la voûte', *Archives de l'Art français*, XXVII, 1985, p.86 n.11 and G. Bresc, 'Problèmes du bronze français: Fondeurs et sculpteurs à Paris (1600–1660)', *ibid.*, xxx, 1989, pp.39–40.

25 C. Jouanny (ed.), 'Correspondance de Nicolas Poussin', *Archives de l'Art français*, nouvelle période, V, 1911, pp.64, 80.

26 C. Perrault, *Parallèle des anciens et des modernes*, Paris, 1692, I, pp.196–7: '*Je remarqueray en passant que ce qu'il y a de plus beau au bas relief des danseuses, a esté fait par un Sculpteur de nostre temps; car lorsque le Poussin l'apporta de Rome en France, ce n'estoit presque qu'une ébauche assez informe, & ç'a esté l'aisné des Anguiers qui luy a donné cette élegance merveilleuse que nous y admirons*' (I am extremely grateful to Jennifer Montagu for this reference).

27 On the Louvre relief, see G. Bresc, in *Masterpieces from the Louvre, French bronzes from the Renaissance to Rodin*, cat. exh. Queensland Art Gallery, Brisbane, 1988, no.13.

28 Analysis of the Wallace Collection bronze undertaken by Brian Gilmour at the Royal Armouries. I am grateful to Geneviève Bresc for details of the analysis of the Louvre bronze.

29 See Bresc, *op. cit.* (at note 23 above), p.40 n.1.

Aftermath

1 For this and other information on the Rospigliosi succession, I am extremely grateful to Angela Negro who also generously provided the reference from the inventory drawn up after Camillo Rospigliosi's death in 1769 quoted on pp.65 and 71 below.

2 Fesch's recent acquisition of three Poussin's from the Rospigliosi palace, including the *Rest on the Flight into Egypt* (Fig.14) and *A Dance to the Music of Time* is recorded in a letter from Suvée to Fesch of 31 December 1806 (*Correspondance des Directeurs de l'Académie de France à Rome, nouvelle série, II, Directorat de Suvée, 1795–1807, II*, 1984, p.902; I am grateful to Francis Haskell for this reference).

3 National Gallery Archives, Eastlake Notebooks, 1864, I, f.5r.

4 Andresen 1863, no.401; Wildenstein 1955, no.161.

5 Andresen 1863, no.408; Wildenstein 1955, no.163.

6 Le Comte 1699–1700, II, p.415.

7 The sequence of Almanack prints is in fact unbroken from 1676 to the present. See Peter 1974.

8 Andresen 1863, no.402a; Wildenstein 1962, p.194.

9 Andresen 1863, no.400; Wildenstein 1962, p.187. See also Duplessis 1880, p.164; Maskell 1882, no.62; Halsey 1885, no.154.

10 On which see R. Verdi, 'On the Critical Fortunes – and Misfortunes – of Poussin's "Arcadia"', *The Burlington Magazine*, CXXI, 1979, pp.95–107.

11 M. Roux, *Inventaire du Fonds français, graveurs du dix-huitième siècle, I*, Paris, 1930, p.355, no.86.

12 Thuillier 1994, R56a.

13 S. Leroy-Beaulieu in F. Hamon, C. Mignot, C. Arminjon, and S. Leroy-Beaulieu, *L'Hôtel de Vigny, Cahiers de l'Inventaire, 5*, Paris, 1985, pp.36–8.

14 Gilles Chomer, 'Poussin et Jacques Stella', *Actes du Colloque Nicolas Poussin*, 1994, forthcoming.

15 Le Français de Lalande refers to the 'fine profile' of Summer, referring presumably to the figure of Wealth and thus identifying Pleasure as Spring, in spite of the fact that this upsets the sequence of the seasons.

16 Volkmann's description of 1771 is almost a direct translation of Le Français de Lalande. He makes one alteration in suggesting an eighteen-year-old rather than a fifteen-year-old for Spring.

Poussin, Lord Hertford and British Collectors

1 Waagen 1854, pp.154–61.

2 See Ingamells 1981, no.89 (11 December 1858).

3 The evidence consists of: the inventories of his London and Paris collections taken after his death; eye-witness accounts by critics during his life; loans to exhibitions (for all these see J. Ingamells, *Wallace Collection Catalogue of Pictures*, 4 vols., London, 1985–92, *passim*); also references in the 4th Marquess of Hertford's correspondence with Samuel Mawson (see Ingamells 1981, *passim*).

4 See J. Ingamells, *Wallace Collection Catalogue of Pictures, I*, 1985, and IV, 1992, *passim*.

5 This can be deduced from the sources mentioned in note 3.

6 See F. Haskell, *Rediscoveries in Art*, London, 1976, especially chapters two and three.

7 Ingamells 1981, no.50 (31 July 1854).

8 He certainly visited the British Institution old masters exhibition of 1819: see Ingamells 1981, no.57 (20 July 1855).

9 Ingamells 1981, no.96 (15 July 1859).

10 See D. Carrington, 'Cardinal Fesch, a Grand Collector', *Apollo*, LXXXVI, 1967, pp.346–57, from which the following is drawn.

11 See Blunt 1966, nos.6c, 12c, 57c, 58c, 62, 69c, 100c, 120c, 121, 137c, 149, 166, 173c, 174c, L49 (rediscovered in 1968 in a private collection), R49, R83. The *Holy Family in a Temple* in the Musée Condé, Chantilly (Blunt 1966, no.52), although now identified as from the Fesch collection, has been catalogued most recently as a pastiche in the style of Poussin: see P. Rosenberg and L.-A. Prat, *Nicolas Poussin. La collection du musée Condé à Chantilly*, cat. exh. Musée de Condé, Chantilly, 1994–5, no.8.

12 See E.K. Waterhouse, 'Poussin et l'Angleterre jusqu'en 1744', in A. Chastel (ed.), *Actes du Colloque International Nicolas Poussin*, Paris, 1960, II, p.284.

13 Blunt 1966, no.156c.

14 See K. Scott, 'The Collectors of Poussin's *Venus and Mercury*', in *Nicolas Poussin· 'Venus and Mercury'*, cat. exh. Dulwich Picture Gallery, London, 1986, pp.19–22.

15 See I. Pears, *The Discovery of Painting*, New Haven and London, 1988, especially chapter six and appendices.

16 See Waterhouse, *op. cit.*, pp.288–9.

17 *Ibid.*, pp.290–1.

18 *Ibid.*, pp.291–4 and A. Blunt, 'Poussin and the British Collectors', *Connoisseur*, CCVIII, 1981, pp.118–21. For Paris, see Pears, *op. cit.*, pp.87–92, 214–15.

19 As well as Carlo Maratta's 1705 portrait of the Marchese Niccolò Maria Pallavicini (d.1759), second son of Giulio Rospigliosi's nephew and heir, Giovanni Battista (see above, p.48); see D. Dodd, *Stourhead* [National Trust guidebook], 1990, p.32. For the Poussins see also Blunt 1966, no.159 (*The Choice of Hercules*, at Stourhead) and no.180 (*The Rape of the Sabines*, now Metropolitan Museum of Art, New York).

20 See G. Waterfield, *Rich Summer of Art*, cat. exh. Dulwich Picture Gallery, London, 1988, especially pp.23–4.

21 The 1807 record was set at the Troward sale for the *Bacchanal before a Herm* (Fig.30). See G. Reitlinger, *The Economics of Taste, I*, London, 1961, pp.414–15.

22 Thuillier 1994, no.201.

23 See below, p.65; also Waterhouse, *op. cit.*, p.289.

24 See R. Verdi, 'Situation de Poussin dans le France et l'Angleterre des XVIIIe et XIXe siècles', in Rosenberg and Prat 1994–5, pp.98–104.

25 Ingamells 1981, nos.20, 23, 104.

Critical Fortune

1672

Giovan Pietro Bellori, *Le Vite de' Pittori, Scultori et Architetti Moderni,*
Rome, 1672, pp.447–8.

THE DANCE OF HUMAN LIFE

Besides the mythological subjects already dealt with, we must mention a few moral conceits expressed in painting, amongst which a most beautiful Invention is that of Human Life represented by a dance of four women, similar to the four seasons. [Poussin] has shown Time seated with his lyre, to the strains of which four women, Poverty, Labour, Wealth and Luxury, join hands in a circle, and dance perpetually, changing the fate of men. Each of them expresses her own nature: Luxury and Riches are at the front, the former garlanded with roses and adorned in pomp with flowers, while the latter is crowned with pearls and gold. Behind them Poverty turns, wearing sad clothes, her head wreathed with dry leaves, which signify possessions lost. She is accompanied by Labour who bares her naked shoulders, with tough sunburned arms and, looking at her companion, shows bodily weariness and suffering. At the feet of Time is a small boy, holding and watching an hour-glass filled with sand and numbering the moments of life. On the other side his companion, playing with a pipe as children do, is blowing bubbles of froth and air, which burst in an instant as a token of the vanity and brevity of life. There is a statue of Janus in the form of a Term, and the Sun in his chariot drives across the sky, with his arms wide open within the circle of the Zodiac, in imitation of Raphael, while the Dawn goes before strewing white flowers over the morning, and the dancing Hours [Hore] fly behind. The subject of this moral poem was given to the Painter by Pope Clement IX while he was a Prelate. Nicolò excelled in a conceit of such noble and rare invention and, though the figures are scarcely two palms in height, he was able happily to match in them the sublimity of the Author, who went on to provide the two following Inventions ... [*Time saving Truth* and the *Arcadian Shepherds*].

1688

André Félibien, *Entretiens sur les vies et sur les ouvrages des plus excellens peintres,*
Paris, 1666–88, V (1688), pp.377–8
(1725 ed., IV, pp.86–7).

Would you like to know how he treated moral ideas and allegorical subjects? I will tell you about just three. The first is an image of human life, represented by a dance of four women, who bear some relation to the four seasons, or to the four ages of man. Time, in the figure of an old man, is seated and plays the lyre, to the sound of which the women, who are Poverty, Labour, Wealth and Pleasure, dance in a circle, and seem to join hands alternately one with another, and thereby to signify the continual changes which take place in the life and the fortune of men. It is easy to recognise what these women represent. Wealth and Pleasure appear first, one crowned with gold and pearls, the other decked with flowers, and having a garland of roses on her head. After them is Poverty dressed in a wretched threadbare garment, her head wreathed with branches of dry leaves as a symbol of the loss of possessions. She is followed by Labour who has her shoulders uncovered, her arms skinny and colourless. This woman looks at Poverty and seems to show her that she has a tired body, oppressed by misery. Near Time and at his feet are two young children. One holds an hour-glass and, as he has been contemplating it attentively, he seems to be counting all the moments of life slipping by. The other, at play, blows through a reed from which emerge bubbles of water and air which burst immediately, signifying the vanity and brevity of life.

In the same painting there is a Term which represents Janus. The Sun seated in his chariot, appears in the sky in the centre of the Zodiac. Aurora goes before the chariot of the Sun and scatters flowers over the earth: the Hours who follow her seem to dance as they fly.

1713

Inventario della Guardarobba e Palazzo dell'Ecc.^{mo} S. Duca Gio: Batt.^a Rospigliosi,
26 June, 1713.

A painting on canvas of 4 palms ... [which] represents the four seasons who dance to the sound of Time, the work of Nicolò Pusino.

1700/30

Anonymous inscription on engraving by Bernard Picart (Fig.51).

The Image of Human Life. The different states of human life represented by four women, who personify PLEASURE, WEALTH, POVERTY, and LABOUR; they join hands and form a dance to the sound of a lyre played by TIME. The two first, who represent PLEASURE and WEALTH, are magnificently adorned, the one with a garland of flowers, which she wears as a wreath, and the other with precious garments glittering with gold and pearls. But POVERTY, half naked in wretched clothes, has a wreath only of dry leaves; and LABOUR, weary and overcome with fatigue, seems to move only with

difficulty, and looks sadly at WEALTH, whom she seems to beg for help. Two small children, one holding an hour-glass, the other playing with soap-bubbles, give a sense of the shortness of human life and how filled it is with vanity; and a double-headed Term placed in the foreground represents the past and the future. The Sun, preceded by Aurora and followed by the Hours, appears in the sky and continually pursues his course while life slips away.

1762
Antoine Joseph Dézallier d'Argenville, *Abrégé de la vie des plus fameux peintres,* Paris, 1762, IV, p.31.

When he wanted to represent human life, it was by the dance of four women, who bear some relation to the seasons and to the four ages of man; Time, in the figure of an old man, plays the lyre and sets them dancing. Can a moral be pointed with greater elegance and grace?

1765/6
Anon. [Joseph Jérôme Le Français de Lalande], *Voyage d'un François en Italie, fait dans les années 1765 & 1766,* Venice and Paris, 1769, III, pp.451–2.

The beautiful painting of human life or the seasons by Poussin ... This painting is composed admirably and with all possible wisdom; the group of the seasons is very beautiful, above all Summer has a fine profile. The drawing of the group is pure, and the contours very fluent; the figures have hair-styles and draperies in the taste of the antique; the colour in general is a little crude, and the flesh tones rather ruddy. The chariot of Apollo and his whole train is composed of figures which are too small. It will be found also that the painter has not adequately differentiated the ages of the Seasons; the woman who represents Spring is thirty-years-old and should be no more than fifteen. He has uncovered the shoulders of the one who represents Winter whereas she should be fully clothed.

1769
Inventory following the death of Camillo Rospigliosi, 1769.

[A painting] of 4 palms across representing a Dance of Nymphs, famous work by Niccolò Pussino, old carved and gilded frame [valued at 2,000 *scudi*]

1783
Jacques de Cambry, *Essai sur la vie et sur les tableaux de Poussin,* Rome and Paris, 1783, p.42.

... A certain nicety is also to be found in the painting in which Poussin sets four women dancing to the sound of Time's lyre; the disdain of Wealth who scarcely touches the fingers of Poverty is perhaps a little contrived.

1787
Friedrich Wilhelm Basilius von Ramdohr, *Ueber Mahlerei und Bildhauerarbeit in Rom für Liebhaber des Schönen in der Kunst,* Leipzig, 1787, III, pp.62–3.

The Four Seasons by Poussin ... This composition, particularly in the lower part of the picture, satisfies all the requirements of a good allegory. It can be grasped as a whole but, even if it is not, the expression of the interlinked figures is instantly explicable and interesting. Are not these the Seasons, the images of the cycle of Time, of transience and regeneration? Yes, but above all they are human beings, dancing to the strains of a lyre, while their children play; all this can be thought of as a rural scene, and the expression of happiness, which is sufficiently explained by the action, can leave neither the eye nor the mind unmoved. The figures in the upper half of the picture might just as well have been left out. They contribute nothing to the viewer's understanding and just as little to the pictorial effect. Yet their presence is not inappropriate, and that, given the frequent abuse of allegorical representation, is quite something.

The execution seems to me better here than in many other pictures by our master. The drawing is correct, the bodies of the dancing figures have svelte forms and alternating postures, and the children have the true character of their age. The normal errors of Poussin, however, are not all avoided. The head of Time is meaningless, not to say stupid-looking; the smile of Spring turns into a simpering grin; the draperies are dry, and there is a complete lack of colour and demeanour.

1798
Mariana Starke, *Letters from Italy between the years 1792 and 1798 ...,* London, 1800, II, p.36 (letter XVII, January 1798).

[Palazzo Rospigliosi] ... two pictures by N. Poussin, one representing the Madonna and our Saviour with Angels!!!! and deemed one of his very finest works; the other, the four seasons, or human life, and almost equally fine!!! ...

1803
William Buchanan, *Memoirs of Painting,* II, London, 1824, p.145 (Irvine to Buchanan, 20 September 1803).

You must not expect another N. Poussin, for it is next to impossible to find one. The two Rospigliosi ones, engraved by Morghen *[A Dance to the Music of Time* and the *Rest on the Flight into Egypt]* were offered to sale some time ago, but at enormous prices, and they are such as I suspect would not do in England, being rather dry. That of the allegory on human life, of four figures dancing, and Time playing, has to be sure many beauties. I think 8000 crowns were offered for the King of Naples, and refused.

1806
Pierre Marie Gault de Saint Germain, *Vie de Nicolas Poussin,* Paris, 1806, pp.20–1.

IMAGE OF HUMAN LIFE
Here we have a cheerful picture, announcing itself as such at the first glance, the subject is novel and the basis most moral: it is a picture of the present, the past and the future, the

image of Time, of man, and his spirit.

St Augustine is one of the celebrated authors who offer the most beautiful disquisitions on the course of human life; several chapters of his Confessions contain admirable reflections on the manner in which the human spirit may measure time: 'what is the life of man, if not a continuous dissipation of his heart and spirit?*'. We seem to see Poussin's painting in this very thought.

The learned painter has made a dance of life; and to animate all the ideas enmeshed with the truths which come to mind on this theme, he has chosen from mythology the divinities proper to his subject. This rich mine of poets and painters

> ... offers the mind a thousand different charms,
> ...
> there, to enchant us, all things have their place,
> each one has a body, a soul, a mind, a face;
> Each virtue into a divinity transformed**.

It is thus that genius, delving into the most abstract ideas, can embellish them with pleasant colours to offer them for our admiration and meditation.

Time, in the figure of an old man, is seated; he plays the lyre, to the sound of which four women dance in a circle as an emblem of the four seasons; they represent also Wealth, Pleasure, Labour and Destitution: the distance between them is expressed by the manner in which they touch one another and in the looks they exchange; Wealth smiles disdainfully at Pleasure and scorns Labour and Suffering. Everything in this dance is emblematic: the nuances of the human heart show themselves full of expressions which trace out the vices of man in the inequality of his fortunes ...

* Confess. of S. Aug., liv. XI, chap. 26, 27, 28, 29.
** Boileau, Art poétique, chant III.

1819

Thomas Moore, *Memoirs, Journal and Correspondence of Thomas Moore,* ed. Russell, London, 1853, III, p.69 (11 November 1819).

Went with the Wilbrahams and Lady Davy to finish our view of Cardinal Fesch's pictures, – the Flemish and the French schools ... There is a much admired picture by Nicolo Poussin, the subject of which is poetical enough; the Hours dancing to the sound of a harp played by Old Time, while a little Love is turning the hour-glass at his feet.

1837

John Smith, *A Catalogue raisonné of the works of the most eminent Dutch, Flemish and French painters,* London, 1829–42, VIII (1837), pp.139–40.

An Allegory of Human Life. This picture ... prove[s] that the mind of the painter was strongly imbued with enlarged feelings of moral philosophy. In the subject now under consideration, he evidently intends to infer, that whatever may be the condition of man, pleasure is his object; and in the attainment of this, every class of persons must in some measure contribute. This lesson of instruction is strikingly illustrated by four females, personifying Riches, Pleasure, Labour and Poverty, with their hands entwined, dancing in a ring to the sound of a lyre, played by Time, who is represented under the figure of an old man with wings, seated on the left, with the instrument on his knees, and his attention directed to the dancers, whose movements.

> "Lead in swift round the months and years."

By the side of Time is seated an infant holding up an hour-glass, and, as an object of amusement, watching the moving sand; a second infant sits on the opposite side blowing bubbles, and close to him stands a Terminus with a double face, in allusion to the Past and Future. The period indicated is the morning of life; and in accordance with this, Phoebus is seen in the heavens, mounted in his golden car, drawn by his fiery coursers, attended by the Hours, and preceded by Aurora.

1844

George, Commissaire-expert du Musée Royal du Louvre, *Galerie de feu S.E. le Cardinal Fesch ancien archevèque de Lyon, etc. ou catalogue raisonné des tableaux de cette galerie ...* (sale catalogue), Rome, 1844, pp.60–3.

The Dance of the Seasons or the *Image of Human Life* ...
Regarding the beautiful painting representing the *Arcadian Shepherds,* the compilers of the *Musée Napoléon* say that "as soon as Poussin's name is mentioned, this picture is the one which will be called to mind by all thinking men; the one which smiles on the imagination of the wise; the one which poets cannot admire without seeing in it the presence of the muses". Then developing their analysis further they add: "with what profundity the scene is disposed, with what intelligence it is conceived, with what noble candour it is expressed! Poussin is the painter of Reason, the moralist of all ages, the poet of all nations. For its precision as allegory, and for its poetic and ingenious idea, this painting is the greatest painting in the world".

We think this judgment all the sounder, because we believe it is also applicable, in all its rigour, to our painting which, if only it had spent the last two centuries in a public museum, would have received the same acclaim and attained the same heights of celebrity. But nobody, I think, will dream of reproaching it for not having enjoyed this advantage, which as we know only chance can bestow: rather they will be eager to recognise in it those great strokes which distinguish a masterpiece of the great painter. We may compare it with that so rightly celebrated painting, the magnificent beauties of which have been vaunted; and, recognising that our *Dance of the Seasons,* has perhaps the advantage over the *Arcadian Shepherds* of a superior execution, let us offer an ardent prayer that, in the interests of the arts and study, a public museum will make so precious an acquisition.

1853

Jean Victor Cousin, 'De divers tableaux du Poussin qui sont en Angleterre et particulièrement de L'Inspiration du Poète', *Archives de l'Art français*, III, 1853–5, p.17.

Sometimes even sacred or profane history is insufficient for him: he invents, he uses his imagination, he has recourse to moral and philosophical allegory. It is there perhaps that he is at his most original, and that his thought unfolds in all its liberty and loftiness ... *Time plucking Truth from the clutches of Envy and Discord*, the *Dance of Human Life*, are the celebrated models of this genre.

1857

Gustav Waagen, *A Walk through the Art-Treasures Exhibition at Manchester under the guidance of Dr. Waagen*, London, 1857, p.41, no.35.

Very attractive on account of the slender proportions and the graceful motives of the Seasons, and by the fine and clear keeping.

1857

Charles Blanc, *Les Trésors de l'Art à Manchester*, Paris, 1857, pp.102, 106.

... Human Life by Poussin, an ingot of gold! ... I passed with delight from the teachings of wisdom to the provocations of sensuality. After walking past that noble and severe aspect of nature which Poussin depicted with a grandeur worthy of his soul, I came back to wander under the trees of Watteau's enchanted gardens.

1903

Paul Desjardins, *Les Grands Artistes, Poussin*, Paris, 1903, pp.104–7.

Having finished the series of Seven Sacraments for his great friend [Cassiano dal Pozzo], and bearing in mind the stock of moral force which he had sought to accumulate in them, he declared to Cassiano his preference for classical allegory. "I would wish, if it were possible, that these Seven Sacraments might be converted into seven other stories which would vividly represent the strangest tricks which Fortune has ever played on men, and particularly on those who have made fun of her efforts. These *exempla* would bear no little fruit, perhaps, the sight of them recalling man to a consideration of that virtue and wisdom which must be acquired to remain firm and unmoved by the attentions of this blind madwoman [Fortune]". Thus a composition which he has invested with his own feelings (even though Bellori says that it was suggested to him by Cardinal Rospigliosi) is the *Ballo della Vita Umana*, presently in the collection of the Marquess of Hertford. Four women who personify Opulence, Poverty, Pleasure and Glory, dance a round close to a tomb decked with garlands; an infant watches an hour-glass emptying, another blows bubbles in the air. Here indeed is the vanity of things of chance. The wise stoic may smile at it, but must never be troubled by it.

1914

Walter Friedlaender, *Nicolas Poussin, die Entwicklung seiner Kunst*, Munich, p.80.

Also both philosophical and arcadian ... [is] the no less famous "Dance of the Seasons", more correctly described in Bellori as "Ballo della vita umana" – an allegorical representation of human life; Time strikes up a dance of four women – Wealth and Poverty, Luxury and Labour. The subject of this "moral poem" (from the Dreams of Polyphilus) is said to have been given to the artist by the prelate Rospigliosi, later Pope Clement IX. The very clear transparent tones, the many changeant colours, and the softly coloured landscape, are reminiscent of the small *Finding of Moses*, but the coolness and stiffness of conception recall still more the allegorical ceiling painting for Richelieu; Domenichino's figure of the winged Saturn appears here as it does there. The dance theme of the bacchanals and the "Adoration of the Golden Calf" is here taken up in a more moderate form as befits the melancholy theme and is arrested as if frozen by the rigid framing on both sides.

1914

Otto Grautoff, *Nicolas Poussin, sein werk und sein Leben*, Munich, 1914, I, pp.145–7.

... Whether Poussin derived the figure of Time from antique gems, from Ovid, or from Marino, is difficult to decide. Marino gives a description of Time based on antique examples in the fifty-first verse of the tenth song of the first book of his *Adone* as follows:

The old man is bald and wrinkled, and to his breast,
Fall the white locks of his flowing beard.
With stern countenance and sturdy features,
He is so great that he almost overshadows the sky.
He is nude, with no clothing,
but for a veil of changing hue.
Swift in the race he seems, with feet shod,
And at his shoulders a bird's wings grow.

Thus Poussin has depicted Time, to the sounds of whose lyre dance Voluptuousness and Wealth, Weariness and Poverty in a placid round. The flower-bedecked head of Voluptuousness beckons with its full lips and passionate glance. Wealth, with a chain of pearls in her hair, rests proud in herself. Weariness implores imperturbable Time for release, and Poverty looks longingly up at her. Aurora sheds a rain of flowers over the earth, while the chariot of the Sun follows, drawn by powerful horses. Like all artists of his period, Poussin placed great weight on the clarity and legibility of an allegory. The necessary internal relationship of the ideas he depicts, one with another, creates the completeness of the whole. The delicate means of characterisation, which reveal the artist's subtlety, divide the attention of the spectator evenly between the spiritual and the formal. The figure of Saturn and the *putto* with an hour-glass on the right are balanced by the herm of Janus and a *putto* on the left. The predominant weight of the dancing group falls in the left half of the picture; the figure of Weariness compensates by drawing the dancers to the right; but above all attention is drawn to the right by the

distant view which is made measurable to the eye by the tree in the background. This picture too manifests a rhythmic harmony in which all the intellectual and formal elements play their part.

1914
Emile Magne, *Nicolas Poussin*, Brussels, 1914, p.192.

In Poussin, it has not been sufficiently stated, the thinker coexisted with the poet. There was certainly an antagonism between the two. The one was beguiled by formulas and concerned with method; the other was beguiled by independence. To the thinker, we owe the *Arcadian Shepherds*, the *Dance of Human Life* and so many other deathless creations; to the poet the landscapes, bacchanals, dances, and the mythological evocations and enchantments …

1924
Léon Coutil, *Nicolas Poussin*, I, Les Andelys, 1924, p.47.

… but [in his last years] he is more and more unwell, sadness overwhelms him, and it is in this condition of melancholy that he paints the *Arcadian Shepherds,* and the *Dance of Human Life,* in 1656 which he finishes in 1663 …

1936
Erwin Panofsky, '"Et in Arcadia Ego", on the concept of transience in Poussin and Watteau', *Philosophy and History, Essays presented to Ernst Cassirer*, Oxford, 1936, pp.241–3.

… Most of the symbolical figures and accessories are borrowed from the great iconographical handbook of the period, Cesare Ripa's *Iconologia,* and the main idea can be ultimately traced to the well-known 'Wheel of Fortune', a favourite conception in medieval art, which represented Man's destiny as a sequence of rising, falling, and rising again ('I rule, I have ruled, I am deprived of my kingdom, I shall rule', as the usual inscription puts it); in French and English Renaissance poetry this idea had already been transformed in such a way as practically to anticipate Poussin's conception: 'Peace' makes 'Plenty', 'Plenty' brings 'Envy', 'Envy' brings 'War', 'War' brings 'Poverty', and 'Poverty' brings 'Peace', and in some versions the Christian virtue of 'Patience' or 'Humility' is inserted as an intermediary between 'Poverty' and 'Peace'. There are, however, startling differences between these prototypes and Poussin's representation: Ripa's images were amusingly encumbered with attributes: 'Fatica', for example, was shown as a vigorous maiden, her dress tucked up, her arms bare to the shoulders, she held a sickle and a flail and was escorted by a bull; 'Poverty' sat on withered branches, and so forth. Poussin manages to transform these images in such a way that the attributes neither prevent the figures from joining hands nor hamper their fluent movements ('Poverty', for instance, wears her withered branches as a becoming wreath). While in the medieval 'Wheels of Fortune', and even in such late poems as the Elizabethan *Histriomastix,* the revolving of Fate was caused by a superhuman or at least preter-human force, whether blind Fortune or an immanent evolutionary principle – Poussin imagines the cycle as a dance performed by handsome female figures who, though subject to the implacable laws of cosmic time, nevertheless within these limits can move freely and connect rhythmically with one another, thereby impressing us as self-sufficient organisms; and while before no active human effort had participated in what Clément Marot had called 'the endless chain of our deeds' (for 'Humility' is but a passive willingness to accept the decrees of God), Poussin inserts *Fatica*, the autonomous and active human endeavour, as a means of turning Poverty into Wealth. Thus Poussin's conception of life as a condition free though fatebound, dignified though pathetic, imperishable though variable, transpires even in a composition which seems to be nothing but the offshoot of a rather conventional allegorical tradition, while its subject was suggested, it seems by an 'outsider', the learned and poetical Prelate Rospigliosi later on Pope Clement IX.

1949
Walter Friedlaender (in collaboration with Anthony Blunt and Rudolf Wittkower), *The Drawings of Nicolas Poussin, Catalogue raisonné,* II, London, 1949, p.24, no.149.

The drawing in general is very close to the painting. The dancing group is almost identical in pose, though the characterization is different. In the drawing Luxury, on the left, has a peacock as a head-dress, an attribute derived from Pierio Valeriano (Bk.24). In the painting this is left out, and Luxury wears instead a wreath of flowers. Wealth, on the right in the foreground, and Labour, at the back, have no clear distinguishing marks in the drawing, but in the painting they have pearls and dry leaves respectively in their hair. Poverty, on the extreme right of the group, is shown in the drawing with her hair flying wildly, but in the painting she wears a rough cap. The chariot of the sun is far nearer and therefore more prominent in the drawing than in the picture, and the circle of the Zodiac is reduced in the latter to a sort of hoop across which Apollo stretches.

These changes are only part of the general evolution towards greater classicism which takes place between the drawing and the painting. In the latter the composition is built up strictly as a bas-relief and is divided into two parts by a horizontal line formed by the tops of the herm, the dancing figures and the empty pedestal on the right, cf. also the symmetrical arrangement of the *putti*. The warm chiaroscuro of the drawing gives place to a more marble-like severity.

1951
Anthony Blunt, *Poussin, The Golden Calf in the National Gallery, London,* London, 1951, p.9.

… the idea of a group dancing in round was to linger in Poussin's mind and just before the visit to Paris, probably in 1639 or 1640, he gave it its final and most classical expression in the *Dance to the Music of Time* in the Wallace Collection. Here as befits the more contemplative mood of the painting the

movement is less violent and the arrangement in a bas-relief pattern more severe. Notice, for instance, that Poussin has eliminated the figure going under the joined hands of two other dancers, a motive which inevitably involves a movement into the picture. In fact, in this final version they approach once more the solemnity of their original prototype, the Borghese relief. This is the last time that such a dancing group appears in Poussin's work. After his return to Rome in 1642 his heroic subjects and his new severity of style do not admit of dancing. His figures may move or gesticulate to express action or emotion, but the pure rhythm of the dance was not rational enough for the master in his later phase.

1951
Anthony Powell, *A Question of Upbringing,*
London, 1951, (ed. 1969), p.2.

For some reason, the sight of snow descending on fire always makes me think of the ancient world ... These classical projections, and something in the physical attitudes of the men themselves as they turned from the fire suddenly suggested Poussin's scene in which the Seasons, hand in hand and facing outwards, tread in rhythm to the notes of the lyre that the winged and naked greybeard plays. The image of Time brought thoughts of mortality: of human beings, facing outward like the Seasons, moving hand in hand in intricate measure: stepping slowly, methodically, sometimes a trifle awkwardly, in evolutions that take recognisable shape: or breaking into seemingly meaningless gyrations, while partners disappear only to reappear again, once more giving pattern to the spectacle: unable to control the melody, unable, perhaps, to control the steps of the dance.

1962
Denis Mahon, 'Poussiniana, Afterthoughts arising from the exhibition', *Gazette des Beaux-Arts,* 6e, LX, 1962, pp.105–6.

The Wallace Collection *Dance of Human Life* is usually placed very late in the decade, around 1639–40. The reason for this was presumably because the disposition was considered "classic" (very understandably) and, since Poussin's last two and a half years or so before his departure for Paris were evidently characterized by a more thoroughgoing classicism than hitherto, it has been thought that the picture must be located then. There are, however, other elements in it which do not entirely fit in with this view. A difficulty is that the painting has strong "romantic" undertones which differ markedly from a whole group of pictures which can only be located in the final pre-Parisian phase. Unfortunately the true tonality of the Dance is somewhat veiled by discoloured varnish, but must surely still have been rather hot in the manner of what we have called the "pseudo-baroque" works. The attitude towards landscape and atmosphere is quite foreign to the clear, unmysterious sweep of the terrain in several of its proposed neighbours. The figures still retain a certain robustness which tends to yield to an exceptional suppleness in pose and gesture towards the end of the decade. And finally there are still passages with something of a painterly touch, giving a relatively free, rich effect which is more characteristic of the earlier group than the later. When all this is borne in mind, it seems arguable that the *Dance of Human Life* could reasonably be placed in about 1637–1638: a prelude in certain respects to the more classic phase which ensues. If on the other hand it were slightly later, which no doubt remains possible, though perhaps less likely, it would represent a different form of "overlapping": a prolongation of something of the romantic atmosphere of the previous phase into a period of cooler, enhanced "classicism" – and so something of an exception [Mahon now favours a date of 1634/5].

1975
Anthony Powell, *Hearing Secret Harmonies,* London, 1975, p.33.

Ariosto's Time – as you might say, Time the Man – was, anthropomorphically speaking, not necessarily everybody's Time. Although equally hoary and naked, he was not Poussin's Time, for example, in the picture where the Seasons dance, while Time plucks his lyre to provide the music. Poussin's Time (a painter's Time) is shown in a sufficiently unhurried frame of mind to be sitting down while he strums his instrument. The smile might be thought a trifle sinister, nevertheless the mood is genial, composed. Ariosto's Time (a writer's Time) is far less relaxed, indeed appallingly restless ...

1976
Anthony Blunt, 'Poussin's "Dance to the Music of Time" Revealed', *The Burlington Magazine,* CXVIII, 1976, p.844.

Poussin's *Dance to the Music of Time* in the Wallace Collection has recently been cleaned with spectacular results. It is a picture that we have all known and respected but under its deadening – rather than discoloured – varnish it had a sad quality which prevented one from loving it. I had myself regarded it as illustrating the rather awkward transition which Poussin was passing through between the rich colour and free handling of the mid-1630's and the austere classicism of the 1640's. Now I should be inclined to reverse the formula and say that the Dance combines in an astonishing manner the qualities of the two styles. What appeared to be a certain dryness of handling is now seen to be deliberate control of a brush which was shaking with nervous energy. The colours which seemed dead, almost leaden, now shine out, like the Venetian tones of the earlier paintings, qualified by a coolness which matches the deliberate beauty of the design and the contemplative character of the subject. It has always provoked comparison with the dancing groups in the *Golden Calf* or the *Bacchanal with a Herm of Pan* (both in the National Gallery) and hitherto their vivacity has seemed to carry the day. Now one can argue that the restrained concentration of the Wallace picture puts it at least on the same level as the other two masterpieces ...

1986

Jonathan Miller, *Subsequent Performances,*
London, 1986, pp.192–3, 196.

'... I decided to go back to Poussin for my
choreography. Every movement, down to the
last detail, was choreographed on the basis of
his pictures. There are two famous canvases in
which dances are represented: one of them
is *The Dance to the Music of Time,* here you see
a ring of dancers with their backs to one
another, arms linked in a circle. They are off-
balance with feet raised and this means that
there is only one position of stability to which
they could return in order to restore balance
so the next step is automatically given. We
worked out the position they must have been
in to reach the one shown. By having those
three steps we had the basis of a dance to
work from. [cf. Fig.25].

1988

Jacques Thuillier, *Nicolas Poussin,*
Paris, 1988, pp.148, 154.

Around 1638 a coldness even appears in
certain paintings which is so blatant that it can
only have been intended. The *Dance of Human
Life* in the Wallace Collection is an example:
the authority of the style conceals only with
difficulty the fact that a certain grace has
disappeared [p.148].

[Rospigliosi] requested at least two
pictures from Poussin, certainly in the years
1637–1640, and himself provided the themes:
The Dance of Human Life and *Time saving Truth
from the attacks of Envy and Discord.* Doubtless
he discussed with the painter the particular
narrative treatment which would make these
subjects true 'moral poems'. Poussin, always
close to history and its foundation in firm fact,
was thus led by this friendly cardinal into the
world of allegorical composition that was so
dear to the seventeenth century. He must have
accepted with pleasure, but without seeing his
path. Perhaps these two canvases, the most
intellectual which he painted, made clear to
him the limits of a poetry which owes too
much to mere feats of intellect [p.154].

1990

Alain Mérot (tr. Fabia Claris), *Nicolas
Poussin,* London, 1990, pp.92–5.

The fourth in this group of pictures
[commissioned by Rospigliosi] again takes up
the theme of the passage of time and the
precarious nature of all happiness, but is
pedantic rather than elegiac. The *Dance to the
Music of Time* ... is neither very well known
nor particularly well liked, yet the mood of
calm contemplation which pervades it makes
this one of the most striking moral *poesie* of
the period. The picture is polished, and makes
skilful use of colour, setting patches of white,
yellow and blue against a muted background.
The composition is simple, but unusual. Based
once again on the triple groupings with which
Poussin was so obsessed, it also features
strongly symmetrical elements.

1991

Alfred Corn, 'Living for the Moment',
ARTnews, November 1991, p.76.

... But why then should a Cardinal and future
pope commission such a pagan scene? The
answer is simply that the work is allegorical,
for among Christ's attributes is his own
Apollonian radiance. He is the Sun of
Righteousness whom all believers, in their
varying degrees, are called on to imitate. Papal
office confers an identity itself akin to the
divine, as the primate is the bridge builder
between earth and Heaven ...

1993

David Carrier, *Poussin's Paintings. A Study
on Art-Historical Methodology,* Pennsylvania
State University, 1993, pp.63–4.

... These clichés appear in a purely literary
evocation of the painter, the brief account of
his *Dance to the Music of Time* in the second
paragraph of Anthony Powell's novel of that
title [see 1951 above]. The narrator imagines
"the ancient world" that suddenly suggested
Poussin's picture. That image "brought
thoughts of mortality," of the seasons moving,
"sometimes a trifle awkwardly"; of the dance
in which partners reappear, "once more giving
pattern to the spectacle" and then of "days at

school." Here are five lexias: 1. the ancient
world; 2. mortality; 3. awkwardness; 4.
creating order from chaos; 5. intellectual
activity. They are common in the Poussin
literature.

1994

Jacques Thuillier, *Nicolas Poussin,*
Paris, 1994, pp.19–23.

If Poussin scarcely illustrated the poets, he at
least painted a series of "moral poems", to use
Bellori's term, which is to say paintings of
moral reflexion which set out to be poems in
themselves. But here a problem arises which
has been too often overlooked. In front of
every work of the seventeenth century, even
in the case of Poussin, it should be asked
whether the subject in fact arises from the
choice and the meditation of the artist, or
whether it was proposed to him by some
scholarly friend who worked up the theme and
the essential elements. With all due respect to
present critics, the point is an important one.
Around 1638–40, for example, one sees
Poussin, contrary to his normal practice,
resorting to the language of allegory for two
very literary paintings: *Time snatching Truth
from the clutches of Envy and Discord* and the
Dance of Human Life, where the themes of
time, fate and the seasons intersect. Now,
Bellori, describing these works, takes
particular trouble to specify that their 'author'
is Giulio Rospigliosi, or the future Clement
IX, and that Poussin was as it happens only
the 'happy translator' who showed himself
worthy of the 'sublimity' of these inventions.

*All translations above are the present author's unless
otherwise stated. They remain fairly literal out of a
desire not to distort the meaning of the original,
even at the expense of style.*

Originals of foreign texts

Giovan Pietro Bellori, *Le Vite de' Pittori, Scultori et Architetti Moderni*, Rome, 1672, pp.447–8.

IL BALLO DELLA VITA HVMANA

Oltre le fauole esposte riferiremo alcuni concetti morali espressi in pittura, trà li quali bellissima è l'inventione della vita humana nel ballo di quattro donne simili alle quattro stagioni. Figurò il Tempo à sedere con la lira, al cui suono quattro donne, la Pouertà, la Fatica, la Ricchezza, e'l Lusso scambieuolmente si danno le mani in giro, e danzano perpetuamente, variando la sorte de gli huomini. Ciascuna di loro esprime la sua propria forma: stanno auanti il Lusso, e la Ricchezza, questa coronata di perle, e d'oro, quella inghirlandata di rose e di fiori pomposamente adorne. Dietro volgesi la Pouertà in habito mesto, cinta il capo di secche frondi, in contrasegno de' perduti beni. Viene ella accompagnata dalla Fatica, la quale scopre le spalle ignude, con le braccia indurate, e brune, e riguardando la sua compagna, mostra lo stento del corpo e'l patimento. A piedi il Tempo vedesi vn fanciullo, il quale tiene in mano e contempla vn oriuolo a poluere numerando i momenti della vita. Dal contrario lato il compagno, come sogliono i fanciulli per giuoco, spira da vn cannellino col fiato, globi di spuma, e d'aria, che si struggono in vn momento, in contrasegno della vanità, e breuità della vita medesima. Euui la statua di Giano in forma di Termine, e scorre in aria il Sole nel carro con le braccia aperte entro la fascia del Zodiaco, ad imitatione di Rafaelle, precedendo l'Alba, che sparge candidi fiori sù'l mattino, e dietro seguitano danzando le Hore à volo. Il soggetto di questa morale poesia fù dato al Pittore da Papa Clemente IX in tempo che egli era Prelato. Preualse Nicolò nel concetto di si nobile e peregrina inuentione, & ancorche le figure siano appena due palmi, potè corrispondere in esse felicemente alla sublimità dell'Autore, che aggiunse le due seguenti inuentioni ...

André Félibien, *Entretiens sur les vies et sur les ouvrages des plus excellens peintres*, Paris, 1666–88, V (1688), pp.377–8 (1725 ed., IV, pp.86–7).

Voulez-vous sçavoir comment il a traité des pensées morales & des sujets allegoriques? Je vous en diray seulement trois. Le premier est une Image de la vie humaine, représentée par un bal de quatre femmes qui ont quelque rapport aux quatre saisons, ou aux quatre âges de l'homme. Le Temps sous la figure d'un vieillard, est assis, & jouë de la lire, au son de laquelle ces femmes, qui sont la Pauvreté, le Travail, la Richesse & le Plaisir, dansent en rond, & semblent se donner les mains alternativement l'une à l'autre, & marquer par là le changement continuel qui arrive dans la vie & dans la fortune des hommes. L'on connoist facilement ce que ce [sic] femmes representent. La Richesse & le Plaisir paroissent les premiers, l'une couronné d'or & de perles, & l'autre parée de fleurs, & ayant une guirlande de rose sur la teste. Aprés eux est la Pauvreté vestuë d'un miserable habit, tout délabré, & la teste environnée de rameaux dont les feuilles sont seches, comme le symbole de la perte des biens. Elle est suivie du Travail qui a les épaules découvertes, les bras décharnez & sans couleur. Cette femme regarde la Pauvreté, & semble lui montrer qu'elle a le corps las, & tout abbatu de misere. Proche le Tems & à ses pieds sont deux jeunes Enfans. L'un tient une horloge de sable; & comme il l'a considere avec attention, il semble compter tous les momens de la vie qui s'écoulent. L'autre, en se jôuant, soufle au travers d'un roseau, d'où sortent des boules d'eau & d'air qui se dissipent aussitost; ce qui marque la vanité & la briéveté de la vie.

Dans le même tableau est un terme qui represente Janus. Le Soleil assis dans son char, paroist dans le ciel au milieu du Zodiaque. L'aurore marche devant le char du Soleil, & répand des fleurs sur la terre: les Heures qui la suivent, semblent danser en volant.

Inventario della Guardarobba e Palazzo dell'Ecc.ᵐᵒ S. Duca Gio: Batt.ᵃ Rospigliosi, 26 June, 1713.

Un Quadro in tela di p. 4 ... [che] rapresenta le 4 stagioni che ballano al suono del Tempo, opera di Nicolò Pusino.

Anonymous inscription on engraving by Bernard Picart (Fig.51).

L'Image de la Vie Humaine. Les differens etats de la vie humaine representez par quatre femmes, qui designent le PLAISIR, la RICHESSE, la PAUVRETE, et le TRAVAIL, se donnent mutuellement la main, et forment une danse au son d'une Lyre touchée par le TEMPS. Les deux premieres, qui representent le PLAISIR et la RICHESSE, sont magnifiquement ornées, l'une d'une guirlande de fleurs, dont elle est couronnée, et l'autre d'habits précieux ou l'on voit éclater l'Or et les Perles. Mais la PAUVRETE, a demi-couverte de mauvais vetements, est seulement couronnée de feuilles seches; Et le TRAVAIL, las et accablé de fatigues, semble ne se remuer qu'avec peine, et regarde tristement la RICHESSE, dont il paroit implorer le secours. Deux petits Enfans, dont l'un tient une horloge de sable, et l'autre se joue avec des Bouteilles [sic] de Savon, font sentir le peu de durée de la vie humaine et de combien de vanité elle est remplie; Et un Terme à double face posé sur le devant represente le passé et l'avenir. Le Soleil, precedé de l'Aurore et suivi des Heures, paroit dans le Ciel, et fait continuellement son cours, pendant que la vie s'ecoule.

Antoine Joseph Dézallier d'Argenville, *Abrégé de la vie des plus fameux peintres*, Paris, 1762, IV, p.31.

Quand il a voulu représenter la vie humaine, ç'a été par la danse de quatre femmes, qui ont quelque rapport aux saisons & aux quatre âges de l'homme; le Tems sous la figure d'un vieillard; joue de la lyre & les fait danser: peut-on employer la morale avec plus d'élégance & de grace?

Anon. [Joseph Jérôme Le Français de Lalande], *Voyage d'un François en Italie, fait dans les années 1765 & 1766*, Venice and Paris, 1769, III, pp.451–2.

Le beau tableau de la vie humaine ou des saisons, par le Poussin ... Ce tableau est admirablement composé & avec toute la sagesse possible; le groupe des Saisons est très-beau, l'Eté est sur-tout d'un bon profil. Le dessein de ce groupe est pur, & les contours bien coulans; les figures sont coëffées & drapées dans le goût de l'antique; la couleur générale est un peu crûe & les chairs un peu rouges. Le char d'Apollon & toute sa suite est composé de trop petites figures. On trouve aussi que le Peintre n'a pas assez différencié les âges des Saisons; la femme qui représente le Printemps a 30 ans, & n'en devroit avoir que 15. Il a découvert les épaules de celle qui représente l'Hiver, & il falloit la vêtir entierement.

Inventory following the death of Camillo Rospigliosi, 1769.

[Un quadro] da palmi 4 per traverso rappresentante Ballo di Ninfe, celebre opera di Niccolò Pussino, cornice antica intagliata e dorata [2,000 scudi].
(I am extremely grateful to Angela Negro for this reference)

Jacques de Cambry, *Essai sur la vie et sur les tableaux de Poussin*, Rome and Paris, 1783, p.42.

On trouveroit encore un peu de subtilité dans le Tableau où le Poussin fait danser quatre femmes aux

sons de la lyre du temps; le dédain de la Richesse qui touche à peine les doigts de la Pauvreté, est un peu recherché peut-être.

Friedrich Wilhelm Basilius von Ramdohr, *Ueber Mahlerei und Bildhauerarbeit in Rom für Liebhaber des Schönen in der Kunst*, Leipzig, 1787, III, pp.62–3.

Die Vier Jahreszeiten von Poussin ... Diese Zusammensetzung befriedigt vorzüglich in dem unteren Theile alle Erfordernisse einer guten Allegorie. Sie ist allgemein verständlich, und sollte sie es auch nicht seyn, so bleibt der Ausdruck der vereinigten Personen auch ohnehin erklärbar, und interessant. Sind es nicht die Jahreszeiten, nicht die Bilder des Kreislaufs der Zeit, des Vorübergehens und des Wiederwerdens; gut! so sind es überhaupt Personen, die nach dem Klange einer Leier tanzen, mit ihren spielenden Kindern; das Alles lässt sich in einer ländlichen Scene wohl zusammen denken, und der Ausdruck von Fröhlichkeit, welcher durch die Handlung hinreichend motivirt wird, kann das Auge und den innern Sinn nicht gleichgültig lassen. Die Figuren in der obern Hälfte des Bildes hätten eben so gut wegbleiben können. Zur Verständigung des Betrachters tragen sie nichts bei, und zur mahlerischen Würkung eben so wenig. Inzwischen stehen sie hier nicht unschicklich, und das ist bei dem häufigen Misbrauche allegorische Vorstellungen schon Etwas.

Die Ausführung scheint mir hier besser als in vielen andern Bildern unsers Meisters. Die Zeichnung ist correkt, die Körper der tanzenden Figuren haben swelte Formen und abwechselnde Stellungen, und die Kinder den wahren Character ihres Alters. Die gewöhnlichen Fehler Poussins sind indess nicht alle vermieden. Der Kopf der Zeit ist unbedeutend, um nicht stupide zu sagen; das Lächeln des Frühlings wird zur grinzenden Zirerei; die Gewänder sind trocken, und an Haltung und Colorit mangelt es gänzlich.

Pierre Marie Gault de Saint Germain, *Vie de Nicolas Poussin*, Paris, 1806, pp.20–1.

IMAGE DE LA VIE HUMAINE

Voilà une riante peinture qui se présente telle au premier coup-d'œil, dont le sujet est neuf et le fond très moral: c'est le tableau du présent, du passé, et de l'avenir, l'image du Temps, de l'homme, et de son esprit.

S. Augustin est un des écrivains célèbres qui a donné les plus beaux développements sur le passage de la vie humaine; on trouve dans plusieurs chapitres de ses Confessions des réflexions admirables sur la maniere dont l'esprit peut mesurer le temps: "Et qu'est-ce que

la vie de l'homme, sinon une dissipation continuelle de son cœur et de son esprit*"? On croit voir dans cette pensée le tableau du Poussin.

Ce savant peintre a fait un bal de la vie; et pour animer toutes les idées qui s'enchaînent aux vérités qui viennent à l'esprit sur cet objet, il a choisi dans la mythologie les divinités convenables à son sujet. Cette riche mine des poëtes et des peintres

> ... Offre à l'esprit mille agréments divers,
> Là, pour nous enchanter, tout est mis en usage,
> Tout prend un corps, une ame, un esprit, un visage;
> Chaque vertu devient une divinité**.

C'est ainsi que le génie, en approfondissant les idées les plus abstraites, sait les embellir d'un coloris aimable pour les offrir à l'admiration comme à la méditation.

Le Temps, sous la figure d'un vieillard, est assis; il joue d'une lyre au son de laquelle dansent en rond quatre femmes sous l'emblême des quatre Saisons; elles représentent encore la Richesse, le Plaisir, le Travail, et la Misere: la distance qui les sépare s'exprime dans leur maniere de se toucher et dans leurs regards; la Richesse dédaigneuse sourit au Plaisir et méprise le Travail et la Peine. Tout est emblématique dans ce bal: les nuances du cœur humain s'y montrent pleines d'expressions pour tracer les vices de l'homme dans l'inégalité des conditions ...

* Confess. de S. Aug. liv. XI, chap. 26, 27, 28, 29.
** Boileau, Art poétique, chant III.

George, Commissaire-expert du Musée Royal du Louvre, *Galerie de feu S.E. le Cardinal Fesch ancien archevêque de Lyon, etc. ou catalogue raisonné des tableaux de cette galerie ...* (sale catalogue), Rome, 1844, pp.60–3.

La Danse des Saisons, ou l'Image de la vie humaine
...

A l'occasion du beau tableau représentant les Bergers d'Arcadie, les rédacteurs du Musée Napoléon disent que, "dès qu'on prononce le nom de Poussin, ce tableau est celui de ses ouvrages qui se présente d'abord à l'idée de tous les penseurs; celui qui sourit le plus à l'imagination des sages; celui que les poëtes ne peuvent admirer sans y reconnaître la présence des muses". Puis entrant plus avant dans l'analyse, ils ajoutent: "avec quelle profondeur cette scène est distribuée, avec quelle intelligence elle est pensée, avec quelle noble candeur elle est exprimée! Le Poussin est le peintre de la raison, le moraliste de tous les temps, le poëte de toutes les nations. Comme précision d'allégorie, et comme pensée

poétique et ingénieuse, ce tableau est le premier tableau du monde".

Nous approuverons d'autant mieux la justesse de ce jugement, que nous le croyons applicable, dans toute sa rigueur, à notre tableau, à qui il n'a manqué, pour recueillir les mêmes suffrages et atteindre aussi à la plus haute renommée, que de séjourner deux siècles dans un musée public. Mais personne, je pense, ne songera à lui faire un reproche de n'avoir pas joui de cet avantage, dont on sait que le hazard seul peut disposer: on s'attachera plutôt à y reconnaître les grands traits qui caractérisent un chef d'œuvre du grand peintre. On le rapprochera, pour les comparer, du tableau si justement célèbre dont on a vanté les magnifiques beautés; et, en reconnaissant que notre Danse des Saisons a peut-être sur les Bergers d'Arcadie l'avantage d'une exécution supérieure, on fera comme nous des vœux ardents pour que, dans l'intérêt des arts et des bonnes études, un musée public fasse une si précieuse acquisition.

Jean Victor Cousin, 'De divers tableaux du Poussin qui sont en Angleterre et particulièrement de L'Inspiration du Poète', *Archives de l'Art français*, III, 1853–5, p.17.

Quelquefois même l'histoire sacrée ou profane ne lui suffit pas: il invente, il imagine, il a recours à l'allégorie morale et philosophique. C'est là peut être qu'il est le plus original, et que sa pensée se déploie dans toute sa liberté et dans toute son élévation. ... Le Temps arrachant la vérité aux atteintes de l'Envie et de la Discorde, le Ballet de la vie humaine, sont des modèles célèbres de ce genre.

Charles Blanc, *Les Trésors de l'Art à Manchester*, Paris, 1857, pp.102, 106.

... la Vie humaine, du Poussin, un lingot d'or! ... Tantôt je passais avec délices des enseignements de la sagesse aux provocations de la volupté. Après m'être promené à travers cette noble et sévère nature que le Poussin dessinait grande, comme son âme, je revenais m'égarer sous les arbres des jardins enchantés de Watteau.

Paul Desjardins, *Les Grands Artistes, Poussin*, Paris, 1903, pp.104–7.

Ayant achevé cette série des Sept Sacrements pour son grand ami [Cassiano dal Pozzo], et songeant aux provisions de force morale qu'il eût voulu y déposer, il lui déclare ses préférences pour l'allégorie antique. "Je souhaiterais, s'il était possible, que ces Sept Sacrements

fussent convertis en sept autres histoires où fussent représentés vivement les plus étranges tours que la Fortune aye jamais joués aux hommes, et particulièrement à ceux qui se sont moqués de ses efforts. Ces exemples ne seraient pas de petit fruit à l'aventure rappelant l'homme par leur vue à la considération de la vertu et de la sagesse qu'il faut acquérir pour demeurer ferme et immobile aux efforts de cette folle aveugle [Fortune]". Ainsi une composition où il a mis son sentiment propre (quoique Bellori dise qu'elle lui fut suggérée par le cardinal Rospigliosi), c'est ce Ballo della Vita Umana, à présent chez le marquis de Hertford. Quatre femmes figurant l'Opulence, la Pauvreté, le Plaisir, la Gloire, dansent une ronde auprès d'un tombeau paré de guirlandes; un enfant regarde se vider un sablier, un autre souffle des bulles dans l'espace. Voilà bien la vanité des choses fortuites. Le sage stoïcien peut y sourire, mais ne doit s'en affliger jamais.

Walter Friedlaender, *Nicolas Poussin, die Entwicklung seiner Kunst*, Munich, p.80.

Philosophisch-arkadisch ... ist auch das ebenso berühmte Bild der "Tanz der Jahreszeiten" (London, Wallace-Coll.), bei Bellori richtiger als "Ballo della vita umana" beschrieben – eine allegorische Darstellung des menschlichen Lebens; die Zeit spielt vier Frauen – Reichtum und Armut, Luxus und Arbeit – zum Tanz auf. Das Sujet (aus den Träumen des Polyphilus) zu dieser "morale poesia" soll dem Künstler von dem Prälaten Rospigliosi, dem späteren Papst Clemens IX, gegeben worden sein. Die sehr klaren, durchsichtigen Töne, die vielen changierenden Farben, wie weichdarbige Landschaft, erinnern an die kleine Findung Mosis, noch mehr aber die Kühle und Steife der Auffassung an das allegorische Deckenbild für Richelieu; der geflügelte Saturn Domenichinos findet sich hier wie da. Das Tanzthema aus den Bacchanalen und der "Anbetung des Kalbes" ist hier dem melancholischen Vorwurf entsprechend in gemässigter Form aufgenommen und durch die steife Umrahmung an beiden Seiten wie in Erstarrung festgehalten.

Otto Grautoff, *Nicolas Poussin, sein werk und sein Leben*, Munich, 1914, I, pp.145-7.

Ob Poussin die Gestalt der Zeit antiken Gemmen, Ovid oder Marino nachgebildet hat, ist schwer zu entscheiden. Marino beschreibt in der 51sten Strophe im 10. Gesang des ersten Buches seines Adone nach antiken Vorbildern die Zeit folgendermassen:

"Calvo é il Veglio, e rugoso, e spande al petto
De la barba prolissa il bianco pelo.

Severo in vista, e di robusto aspetto,
E' grande sì, che quasi adombra il Cielo
E'tutto ignudo, e senza vesta, eccetto
Quanto il ricopre un varriabil velo.
Agil sembra nel corso, hà i piè calzati,
Et a guisa d'augel gli homeri alati."

So hat auch Poussin die Zeit dargestellt, zu deren Lyraklängen Wollust und Reichtum, Müdigkeit und Armut im sanften Reigen tanzen. Das blumengeschmückte Haupt der Wollust lockt mit vollen Lippen und heissem Blick. Der Reichtum, eine Perlenkette im Haar, ruht stolz in sich selbst. Die Müdigkeit fleht die unerschütterliche Zeit um Erlösung an, und die Armut hebt sehnsuchtsvoll den Blick zu ihr. Aurora giesst einen Blumenregen auf die Erde; ihr folgt von kräftigen Rossen gezogen der sonnige Wagen. Wie alle Künstler seiner Zeit, legt auch Poussin hohes Gewicht auf die Klarheit und Sinnfälligkeit einer Allegorie. Die innere notwendige Beziehung der dargestellten Ideen untereinander ergibt die Geschlossenheit des Ganzen. Die leisen Mittel der Charakterisierung, die den Takt des Künstlers beweisen, verteilen die Aufmerksamkeit des Beschauers gleichmässig auf das Geistige und Formale. Dem Saturn und dem Putto mit dem Stundenglas rechts entsprechen links die Janusherme und ein Putto. Das Schwergewicht der Tänzergruppe liegt auf der linken Bildhälfte; als Ausgleich zieht die Gestalt der Müdigkeit die Tanzenden nach rechts; vor allem aber winkt rechts die Ferne, die durch den Baum im Hintergrund für das Auge abtastbar wird. Auch in diesem Bild tritt eine Eurythmie in Erscheinung, an der alle geistigen und formalen Elemente mitwirken.

Emile Magne, *Nicolas Poussin*, Brussels, 1914, p.192.

En Poussin, on ne l'a pas assez constaté, cohabitait, avec le penseur, le poète. Il y avait certainement antagonisme entre les deux personnages. L'un était épris de formules et soucieux de méthode, l'autre était épris d'indépendance. Au penseur, nous devons les Bergers d'Arcadie, *le* Ballet de la vie humaine et tant d'autres créations impérissables; au poète, les paysages, les bacchanales, les danses, les évocations et les féeries mythologiques ...

Léon Coutil, *Nicolas Poussin*, I, Les, Andelys, 1924, p.47.

... Mais il est de plus en plus souffrant, la tristesse l'envahit, et c'est sous ces impressions de mélancholie qu'il peint les Bergers d'Arcadie, et le ballet de la vie humaine, en 1656 qu'il termine en 1663 ...

Jacques Thuillier, *Nicolas Poussin*, Paris, 1988, pp.148, 154.

Vers 1638 apparaîtra même dans certains tableaux une froideur si ostensible qu'elle ne peut être que voulue. La Danse de la vie humaine de la collection Wallace en témoigne: l'autorité du style y dissimule difficilement qu'une certaine grâce a disparu [p.148].

[Rospigliosi] demanda au moins deux tableaux à Poussin, certainement dans les années 1637–1640, et en donna lui-même le thème: La Danse de la vie humaine et Le Temps soustrayant la Vérité aux atteintes de l'Envie et de la Discorde. Sans doute en discuta-t-il avec le peintre l'affabulation particulière qui devait en faire de vraies "poésies morales". Poussin toujours proche de l'histoire et de ses données concrètes, se voyait ainsi conduit par un cardinal ami dans le domaine de la composition allégorique si cher au XVIIe siècle. Il dut l'accepter avec plaisir, mais sans y reconnaître sa voie. Peut-être ces deux toiles, les plus intellectuelles qu'il ait peintes, lui firent-elles précisément sentir les limites d'une poésie qui emprunte trop aux seuls prestiges de l'esprit [p.154].

Jacques Thuillier, *Nicolas Poussin*, Paris, 1994, pp.19-23.

Si Poussin n'a guère illustré les poètes, il a du moins peint une série de "poésies morales", selon le terme de Bellori, c'est-à-dire de tableaux à réflexion morale qui se voulaient par eux-mêmes un poème. Mais là se pose un problème trop négligé. Devant chaque œuvre du XVIIe siècle, même s'il s'agit de Poussin, il convient de se demander si le sujet procède bien du choix et de la méditation de l'artiste, ou lui a été proposé par un lettré de ses amis qui en a élaboré le thème et les termes essentiels. N'en déplaise aux commentateurs actuels, le point est de conséquence. Vers 1638–1640, par exemple, on voit Poussin, contrairement à ses habitudes, recourir au langage allégorique pour deux tableaux très littéraires: Le Temps arrachant la Vérité aux atteintes de l'Envie et de la Discorde (no 140) et la Danse de la vie humaine (no 141), où se croisent les thèmes du temps, des sorts et des saisons. Or Bellori, décrivant ces œuvres, prend justement soin de préciser que l'"auteur" en est Giulio Rospigliosi, soit le futur Clément IX, et que Poussin ne fut en l'occurrence que l'"heureux traducteur" qui se montra digne de la "sublimité" de ces inventions.

Bibliography

This is a bibliography of *A Dance to the Music of Time*. Publications referred to in the footnotes which do not mention the Wallace Collection painting (or the preliminary drawing or engravings) are not included here; they are cited in full in the footnotes. The bibliography does not pretend to be comprehensive.

1664 G.P. Bellori, *Nota delli Musei ... di Roma*, Rome, 1664, p.48.

1667/9 Inscription on engraving by J. Dughet and E. Baudet.

1672 G.P. Bellori, *Le Vite de' Pittori, Scultori et Architetti Moderni*, Rome, 1672, pp.447–8

1688 A. Félibien, *Entretiens sur les vies et sur les ouvrages des plus excellens peintres*, Paris, 1666–88, V (1688), pp.377–8 (1725 ed., IV, pp.86–7).

1699–1700 F. Le Comte, *Cabinet des singularitez d'architecture, peinture, sculpture, et graveure*, Paris, 1699–1700, II, p.415, III, p.33.

1700/33 Inscription on engraving by B. Picart.

1713 *Inventario della Guardarobba e Palazzo dell'Ecc^mo. S. Duca Gio: Batt^a. Rospigliosi*, 26 June 1713 (published in Zeri 1959).

1730 E. Wright, *Some Observations made in travelling through France, Italy, &c. in the years 1720, 1721 and 1722*, London, 1730, I, p.310.

1744 F. de' Ficoroni, *Le vestigia e rarità di Roma Antica*, II, *Le singolarità di Roma moderna*, Rome, 1744, p.58.

1762 A.J. Dézallier d'Argenville, *Abrégé de la vie des plus fameux peintres*, Paris, 1762, IV, p.31.

1769 Inventory following the death of Camillo Rospigliosi, 1769.

 Anon. [J.J. Le Français de Lalande], *Voyage d'un François en Italie, fait dans les années 1765 & 1766*, Venice and Paris, 1769, III, pp.451–2.

1771 J.J. Volkmann, *Historische-Kritische Nachrichten von Italien ...*, Leipzig, 1770–1, II, pp.217–18.

1776 G.P. Rossini, *Il Mercurio errante*, Rome, 1776, II, p.125.

1778/90 Inscription on engraving by R. Morghen.

1783 J. de Cambry, *Essai sur la vie et sur les tableaux de Poussin*, Rome and Paris, 1783, p.42.

1787 F.W.B. von Ramdohr, *Ueber Mahlerei und Bildhauerarbeit in Rom für Liebhaber des Schönen in der Kunst*, Leipzig, 1787, III, pp.62–3.

1792 M. Vasi, *Itinéraire instructif de Rome ...*, Rome, 1792, p.308 (first published 1791).

1800 M. Starke, *Letters from Italy between the years 1792 and 1798 ...*, London, 1800, II, p.36.

1806 P.M. Gault de Saint-Germain, *Vie de Nicolas Poussin*, Paris, 1806, pp.20–2.

1815 R.C. Hoare, *Recollections abroad during the years 1785, 1786, 1787*, Bath, 1815, I, p.74.

1816 G. Laoureins, *Tableau de Rome vers la fin de 1814*, Brussels, 1816, p.398.

1823 J.B.M. Gence, Life of Poussin, in *Biographie Universelle ancienne et moderne ... ouvrage ... rédigé par une société de gens de lettres et de savants*, XXXV, Paris, 1823, pp.578, 582.

 A.C. Quatremère de Quincy, *Essai sur la nature, le but et les moyens de l'imitation dans les Beaux-Arts*, Paris, 1823, p.336 n.1.

1824 W. Buchanan, *Memoirs of Painting*, London, 1824, II, p.145.

1837 J. Smith, *A Catalogue raisonné of the works of the most eminent Dutch, Flemish and French painters; in which is included a short biographical notice of the artist, with a copious description of their principal pictures*, London, 1829–42, VIII (1837), pp.139–40.

1840 G. Melchiorri, *Guida metodica di Roma e suoi contorni*, Rome, 1840, p.560.

1841 *Catalogue des Tableaux composant la Galerie de feu son Eminence le Cardinal Fesch*, Rome, 1841, p.48, no.1056.

1844 George [Commissaire-expert du musée royal du Louvre], *Galerie de feu S.E. le Cardinal Fesch ancien archevèque de Lyon, etc ou catalogue raisonné des tableaux de cette galerie ...* (sale catalogue), Rome, 1844, pp.60–3, no.397.

1845 C.P. Landon, *Galerie des peintres les plus célèbres. Œuvres Complètes de Nicolas Poussin*, Paris, 1845, I, p.14, II, pl.199.

1853 T. Moore, *Memoirs, Journal and Correspondence of Thomas Moore,* (ed. Russell), London, 1853, III, p.69.

1853–5 J.V. Cousin, 'De divers tableaux du Poussin qui sont en Angleterre et particulièrement de L'Inspiration du Poète', *Archives de l'Art français,* III, 1853–5, p.17.

1854 G. Waagen, *Treasures of Art in Great Britain,* London, 1854, II, p.156.

1857 C. Blanc, *Les Trésors de l'Art à Manchester,* Paris, 1857, pp.102, 106.
Catalogue of the Art Treasures of the United Kingdom collected at Manchester in 1857, London, 1857, p.76.
A Handbook to the Paintings by Ancient Masters in the Art Treasures Exhibition, being a reprint of critical notices originally published in "The Manchester Guardian", London, 1857, p.76.
G. Waagen, *A Walk through the Art-Treasures Exhibition at Manchester under the guidance of Dr. Waagen,* London, 1857, p.41, no.35.

1861 G. Duplessis, *Histoire de la gravure en France,* Paris, 1861, p.164.

1863 A. Andresen, *Nicolas Poussin, Verzeichniss der nach seinen Gemälden gefertigten gleichzeitigen und späteren Kupferstiche,* Leipzig, 1863, pp.102-3.

1874 C.C. Black, *Catalogue of the collection of Paintings, Porcelain, Bronzes, Decorative Furniture, and other Works of Art, lent for Exhibition in the Bethnal Green Branch of the South Kensington Museum, by Sir Richard Wallace, Bart., M.P.,* London, 1874, p.78.

1882 A. Maskell, *A Catalogue of the engraved works of Raphael Morghen,* London, 1882, p.39, no.62.

1885 F.R. Halsey, *Raphael Morghen's Engraved Works,* New York and London, 1885, pp.139–41, no.154.

1900 *Provisional Catalogue of the Oil Paintings and Water Colours in the Wallace Collection,* London, 1900, p.83.

1903 P. Desjardins, *Les Grands Artistes, Poussin,* Paris, 1903, pp.104, 107.

1909 *Catalogue of the Oil Paintings and Water Colours in the Wallace Collection,* 10th edition, London, 1909, p.148.

1913 *The Wallace Collection Catalogue of Pictures and Drawings,* 13th edition, London, 1913, p.183.

1914 W. Friedlaender, *Nicolas Poussin, die Entwicklung seiner Kunst,* Munich, 1914, pp.80, 126.
O. Grautoff, *Nicolas Poussin, sein werk und sein Leben,* Munich, 1914, I, pp.145–7, II, pp.120–1, no.73.
E. Magne, *Nicolas Poussin,* Brussels, 1914, p.192, p.215, no.278.

1924 L. Coutil, *Nicolas Poussin,* I, Les Andelys, 1924, p.47.

1929 W. Gibson, 'Nicolas Poussin (1593–1665)', *Old Master Drawings,* IV, June 1929, p.6.

1936 E. Panofsky, '"Et in Arcadia Ego", on the concept of transience in Poussin and Watteau', *Philosophy and History, Essays presented to Ernst Cassirer,* Oxford, 1936, pp.241–3, 252–4.

1939 R.-A. Weigert, *Bibliothèque Nationale, Cabinet des Estampes, Inventaire du Fonds français,* Paris, 1939ff., I (1939), p.293.

1946 E. Panofsky, *Studies in Iconology,* New York, 1946, pp.92–3.

1948 P. Jamot, *Connaissance de Poussin,* Paris, 1948, pp.24–5, 41, 81.

1949–74 W. Friedlaender (with A. Blunt and R. Wittkower), *The Drawings of Nicolas Poussin, Catalogue raisonné,* London, 1939–74, II (1949), no.149; IV (1963), p.35 n.1; V (1974), p.100.

1950 E.H. Gombrich, 'The Sala dei Venti in the Palazzo del Tè', *Journal of the Warburg and Courtauld Institutes,* XIII, 1950, p.190 n.2.

1951 A. Blunt, *Poussin, The Golden Calf in the National Gallery, London,* London, 1951, p.9.
A. Powell, *A Question of Upbringing,* London, 1951 (ed. 1969), p.2

1953 J. Bialostocki, *Poussin, I teoria klasycyzmu,* Wroclaw, 1953, pp.12–13, 77 n.32.
A. Blunt, *Art and Architecture in France, 1500–1700,* London, 1953, p.187 (revised ed. 1980, p.282).

1954 F.S. Licht, *Die Entwicklung der Landschaft in den Werken von Nicolas Poussin,* Basle and Stuttgart, 1954, pp.117, 121–2.
R.-A. Weigert, *Bibliothèque Nationale, Cabinet des Estampes, Inventaire du Fonds français,* Paris, 1939ff., III (1954), p.521.

1955 G. Wildenstein, 'Les Graveurs de Poussin au XVIIe siècle', *Gazette des Beaux-Arts,* 6e, XLVI, 1955, p.292, no.161.

1959 F. Zeri, *La Galleria Pallavicini in Roma, Catalogo dei dipinti,* Florence, 1959, pp.319–20, nos.512, 522, p.329.

1960 D. Mahon, 'Poussin's Early Development: an Alternative Hypothesis', *The Burlington Magazine,* CII, 1960, p.304 n.109.
E. Panofsky, *A Mythological Picture by Poussin in the Nationalmuseum Stockholm,* Stockholm, 1960, pp.30–1.
C. Sterling, 'Biographie', in cat. exh. *Nicolas Poussin,* Musée du Louvre, Paris, 1960, p.235.
J. Thuillier, 'Tableaux attribués à Poussin dans les Galeries italiennes', in A. Chastel (ed.), *Actes du colloque International Nicolas Poussin,* Paris, 1960, II, p.273.

1962 D. Mahon, in *L'Ideale Classico del Seicento in Italia e la pittura di paesaggio,* cat. exh. Palazzo dell'Archiginnasio, Bologna, 1962, p.156.

D. Mahon, 'Poussiniana. Afterthoughts arising from the exhibition', *Gazette des Beaux-Arts,* 6ᵉ, LX, 1962, pp.105–6.

G. Wildenstein, 'Catalogue des graveurs de Poussin par Andresen ... traduction française abrégée, avec reproductions', *Gazette des Beaux-Arts,* 6ᵉ, LX, 1962, pp.187, 194.

1965 A. Blunt, 'Poussin and his Roman Patrons', *Walter Friedlaender zum 90. Geburtstag,* Berlin, 1965, pp.62, 65–6.

1966 A. Blunt, *The Paintings of Nicolas Poussin, A Critical Catalogue,* London, 1966, pp.81–2, no.121.

W. Friedlaender, *Nicolas Poussin. A New Approach,* London, 1966, pp.39, 46.

1967 A. Blunt, *Nicolas Poussin, The A.W. Mellon Lectures in the Fine Arts, 1958, The National Gallery of Art, Washington, D.C.,* London and New York, 1967, pp.151, 153.

1969 K. Badt, *Die Kunst des Nicolas Poussin,* Cologne, 1969, I, pp.201–2, 524, 543–4.

J. Thuillier, *Nicolas Poussin,* Novara, 1969, pp.117–18

1972 A.P. de Mirimonde, 'Poussin et la musique', *Gazette des Beaux-Arts,* 6ᵉ, LXXIX, 1972, pp.143–4.

1974 H.M. Peter, *The Oxford Almanacks,* Oxford, 1974, pp.6, 38–9.

J. Thuillier, *L'opera completa di Poussin,* Milan, 1974, p.101, no.123.

1975 A. Powell, *Hearing Secret Harmonies,* London, 1975, p.33.

1976 A. Blunt, 'Poussin's "Dance to the Music of Time" Revealed', *The Burlington Magazine,* CXVIII, 1976, pp.844–8.

1979 A. Blunt, *The Drawings of Poussin,* New Haven and London, 1979, pp.47, 51.

1980 F. Haskell, *Patrons and Painters,* New Haven and London, 1980, p.57.

D. Wild, *Nicolas Poussin,* Zürich, 1980, I, pp.59, 202, 215, II, p.90, no.95.

1981 J. Ingamells (ed.), *The Hertford Mawson Letters, The 4th Marquess of Hertford to his agent Samuel Mawson,* London, 1981, p.27.

1982 H.D. Russell, *Claude Lorrain 1600–1682,* cat. exh. National Gallery of Art, Washington – Grand Palais, Paris, 1982, p.407.

1984 *Correspondance des Directeurs de l'Académie de France à Rome, nouvelle série,* II, *Directorat de Suvée, 1795–1807,* Rome, 1984, II, p.902.

1985 C. Wright, *Poussin Paintings. A Catalogue raisonné,* London, 1985, p.192, no.115.

1986 J. Miller, *Subsequent Performances,* London, 1986, pp.192–3, 196.

1988 J.-J. Lévêque, *La vie et l'œuvre de Nicolas Poussin,* Paris, 1988, pp.62–3.

J. Thuillier, *Nicolas Poussin,* Paris, 1988, pp.148, 154.

1989 M. Bull, 'A Dance to the Music of Space', *Art History,* 12, 1989, p.516.

J. Ingamells, *The Wallace Collection Catalogue of Pictures,* III, *French before 1815,* London, 1989, pp.307–13.

1990 A. Mérot, *Nicolas Poussin,* London, 1990, pp.92–5.

M.R. Lagerlöf, *Ideal Landscape, Annibale Carracci, Nicolas Poussin and Claude Lorrain,* New Haven and London, 1990, p.200.

1991 A. Corn, 'Living for the Moment', *ARTnews,* November 1991, pp.75–6.

1993 D. Carrier, *Poussin's Paintings, A Study in Art-Historical Methodology,* Pennsylvania State University, 1993, pp.31, 63–4, 101 n.85, 185, 231.

1994 Jean Jacques Lévêque, *Nicolas Poussin,* 1994, p.43.

P. Rosenberg and V. Damian, *Nicolas Poussin,* Paris, 1994, pp.70–3.

P. Rosenberg and L.-A. Prat, *Nicolas Poussin 1594–1665. Catalogue raisonné des Dessins,* Milan, 1994, no.144.

J. Thuillier, *Nicolas Poussin,* Paris, 1994, pp.19–23, 119, 256, no.141.

1994–5 E. Fumagalli, 'Poussin et les collectionneurs romains au XVIIᵉ siècle', in *Nicolas Poussin 1594–1665,* cat. exh. Grand Palais, Paris, 1994–5, pp.51, 52 n.47.

P. Rosenberg and L.-A. Prat, *Nicolas Poussin, 1594–1665,* cat. exh. Grand Palais, Paris, 1994–5, pp.276, 278–9.

A. Schnapper, 'Inventaires après décès et amateurs de Poussin à Paris au XVIIᵉ siècle', in *Nicolas Poussin 1594–1665,* cat. exh. Grand Palais, Paris, 1994–5, p.71.

J. Thuillier, 'Poussin et Dieu', in *Nicolas Poussin 1594–1665,* cat. exh. Grand Palais, Paris, 1994–5, p.33.

Index